CENTRAL BIRMINGHAM

THROUGH TIME

Eric Armstrong &
Vernon Frost

AMBERLEY PUBLISHING

Acknowledgements

Th authors wish to extend a warm 'thank you' to the unknown members of the public and Council employees who responded to our varied enquiries in the breezy and kind-hearted manner of the Brummie.

First published 2009

Amberley Publishing Plc
Cirencester Road, Chalford,
Stroud, Gloucestershire, GL6 8PE

www.amberley-books.com

Copyright © Eric Armstrong & Vernon Frost, 2009

The right of Eric Armstrong & Vernon Frost to be identified as the Authors of this work has been asserted in accordance with the Copyrights, Designs and Patents Act 1988.

ISBN 978 1 84868 545 1

British Library Cataloguing in Publication Data.
A catalogue record for this book is available from the British Library.

Typeset in 9.5pt on 12pt Celeste.
Typesetting and Origination by Amberley Publishing.
Printed in Great Britain.

Introduction

'Well, I remember when a professional footballer was paid no more than the maximum wage of ten quid a week, a packet of ten fags cost four pence and there were no underpasses or flyovers in Brummagem.'

Very few adults can have missed becoming involved in comparing 'then' with 'now', often with the intention of 'proving' one state of affairs to be better than another. For the most part, however, such an evaluation process is not followed in this book. In essence, the photographs are allowed to speak for themselves. But some explanatory text is added, hopefully to provide a better understanding of what appears in the illustrations. After all, a snapshot is just that, and can be misleading unless set in an appropriate context.

As some of the pictures date from more than a century ago, we are looking at a legacy of Edwardian, Victorian and even earlier days. It therefore seems appropriate to weave together some of the main strands of Birmingham's development between the 1750s and 2009.

By the mid-eighteenth century, many Birmingham folk were busy in small workshops manufacturing a variety of metal goods, from nails to pots and pans, ladles to metal buttons. For the last named product, the town acquired a widespread reputation, eventually becoming the button-making centre for the whole country. The skills of the smiths who turned out guns and those of master craftsmen in the jewellery trade became legendary. The jewellery craftsmen tended to concentrate in a relatively small and congested part of the town, later to become known worldwide as the Jewellery Quarter, happily still in business and now a tourist attraction.

But the real impetus to the astonishing industrial growth came from the enterprise and abilities of three men who made vital contributions to the emergent Industrial Revolution. In 1956, in a printed programme for the public unveiling in Broad Street of the memorial statues to Boulton, Watt and Murdoch the following succinct and elegant praise is paid to these men.

> *Matthew Boulton (1728-1809), was a Birmingham manufacturer who acquired an outstanding international reputation for the high quality of his products and for his advanced methods of industrial organisation.*
>
> *James Watt (1736-1819), Boulton's partner, improved and developed the steam engine. His strength lay in his ability to combine theory and practice, and by his inventive genius to make the steam engine a commercial proposition.*
>
> *William Murdoch (1754-1839), during his association with Boulton and Watt, discovered practical methods of making, storing and purifying coal gas for lighting purposes. He was also responsible for many important improvements in steam machinery.*

Of course, other very able men helped to put Birmingham on the map. These included: Joseph Priestley, the discoverer of oxygen and held to be 'the father of modern chemistry'; John

Baskerville, printer, master type-founder and inventor of the Baskerville type of worldwide use; brothers George and Richard Cadbury; John Bright, respected M.P., and, of course, Joseph Chamberlain, of whom more later.

The nineteenth century brought the massive expansion of manufacturing industry, principally associated with the metal trades and greatly assisted by the spread of networks of railways and canals. The latter part of the nineteenth and early part of the twentieth century brought industrial titans striding onto the stage, major Birmingham employers with names known throughout the trading world, including: Averys, Austin, BSA, Cadburys, Dunlop, Fisher and Ludlow, GEC, GKN, Kynoch, and Lucas.

The pace and scale of such industrial expansion far outstripped that of political change. In the struggle for democracy, concessions in the direction of universal suffrage were slow, limited and grudgingly made by parliament. In Birmingham an important growth point was reached in 1838 when the town was granted, by royal charter, a measure of self-government. (In July 1938, to mark the centenary of that historic step forward, Birmingham engaged in week-long celebrations, including a pageant, concerts, parades, and so forth). With later legislation, for example the 1851 Improvement Act, Birmingham Council gained complete control of its roads, lighting, sewers and sanitation, public buildings, markets and baths.

Steadily, through changes in legislation and by increasing practical experience, the council became a major municipal authority to be held up as a model for other local authorities to follow. Dynamic and visionary leadership was provided by Joseph Chamberlain, 'Radical Joe' to his many supporters, who served as mayor between 1873 and '76. Dramatic, far-reaching public takeovers began. In 1875, the gas supply came under municipal ownership and control; 1876, water; 1898, electricity; 1904, tramways. Later, municipal housing and banking were introduced. In 1919, the municipal orchestra was formed, and twenty years later the municipal airport at Elmdon was opened.

The last century brought other radical changes to the city. Two World Wars occupied nearly ten percent of those hundred years. During both wars, Birmingham's factories became massive producers of major importance of arms and ammunition. As such they became, principally in 1940 and 1941, natural targets for the German Luftwaffe. Factories and houses alike suffered great damage. The grey, grim days following the end of the Second World War brought, to be paradoxical, an abundance of shortages, and a period of austerity. Some municipal powers, such as the provision of electricity, were transferred to purpose-designed national institutions. Birmingham's own industrial structure underwent radical change, with major factories closing down, and hitherto household names disappearing from sight, if not from memory. The 'workshop of the world' passed into history. By this time, many immigrants, often from Commonwealth countries, had come to live and work in the city. Whatever the changing mix in the economic structure of the city and its population, no shortage of challenges faced the council. Not least were issues of redevelopment. What was to be done about traffic congestion? What was to be done about the Bullring? Such questions had become perennial.

As the standard of living rose, so did imaginative redevelopment, especially in the heart of the city, as featured in this book. One landmark was the Rotunda in New Street, a circular tower built during 1964-5. In 1972, the city went 'one higher' with the construction of the Alpha

Tower near Broad Street, a building of unusual shape containing twenty-seven floors for office workers. But the Bullring? What was to be done there? Given the increased frenetic interaction between traffic and trade something drastic was needed — but what? An ultra-modern design was decided upon and, in 1964, following the widening of various roads and the creation of the Inner Ring Road, the new Bullring Shopping Centre was opened. Part of this essentially concrete complex constituted a traffic-free, open air space of market stalls, some of them canopy-covered. But, for whatever reasons, the new venture did not succeed and the whole area became rather run down and grubby.

Try again. At the start of the new millennium, bulldozers and cranes set to work and, in 2003, the grand new store of Selfridges, of radical design, opened its doors to eager and expectant shoppers. Elsewhere in the city centre, other exciting developments had taken place: to give the shopper an advantage over the motorist, much of New Street, all of the High Street, and some of the smaller adjacent roads became 'Pedestrian Zones', with vehicles being generally excluded. Restricted traffic access applied to other inner city streets.

Some of the most striking and popular changes were carried out on the northern side of Broad Street. Smart new shops, cafés, and restaurants are to be found in the greatly spruced-up Brindleyplace. Close by, Centenary Square is to be found, holding the Repertory Theatre, the International Convention Centre, the National Indoor Arena and, perhaps the jewel in the crown, Symphony Hall.

A short distance away stands the council house. Clearly, the differences between the 'then' and 'now' of this seat of government lie less in the outward appearance of the building, and more in the immediate surroundings, a feature common to many other comparisons.

For the most part, the illustrations are arranged in the sequence that reflects the routes that someone strolling around the city might take, occasionally turning around to look back. Conscientious, even strenuous and elderly athletic attempts have been made to locate the same viewpoints used by earlier photographers. Complete success was not always possible. Trampling about a flower bed was just 'not on', while levitating above the 'concrete collar' of the inner ring road was a frivolous fleeting fancy. A few uncertainties remain: for example, the distances Nelson's statue was moved in height and length. Occasionally, by a considered adjustment of a few yards, or viewpoint angle, a modern photograph has been made more interesting. In short, we have allowed ourselves a touch of artistic licence, as Brummies in general have done, in the city centre.

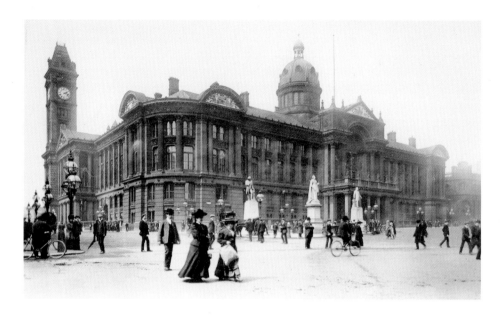

Council House and Art Gallery

This building, in Renaissance style, was completed in 1879. Ten years later, when Birmingham was formally awarded city status, the adjoining art gallery, with its clock tower, opened. For the greater part of its history, this seat of local government was not seen to best advantage. Increasing motor traffic necessitated the introduction of traffic control schemes, including changing sizes of roundabouts, and a one-way system of traffic flow. But now Victoria Square has become the indisputable domain of the pedestrian who, from a variety of vantage points, can appreciate this building, standing proudly amid its beautifully paved environment.

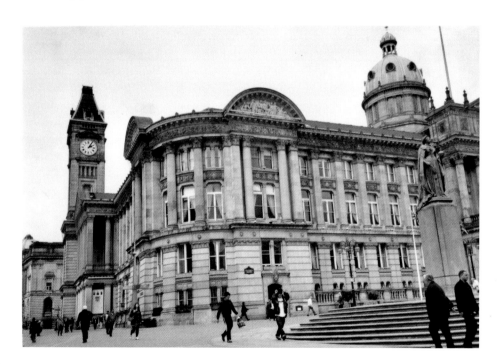

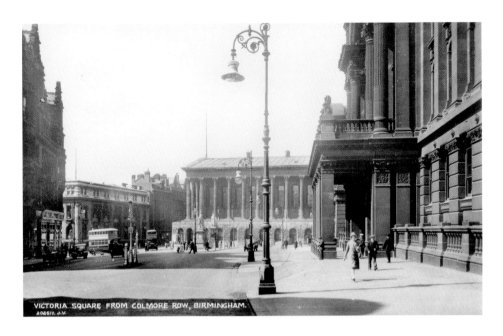

VICTORIA SQUARE FROM COLMORE ROW, BIRMINGHAM.

Council House and Town Hall
Given the lady's cloche hat, the earlier scene probably dates from the late 1920s. A double-decker bus is emerging from Paradise Street and another from the New Street/Hill Street direction. The well-cleaned stone of the Council House positively glows in late afternoon sunshine. Even at a distance, the modern Alpha Tower seems to loom over the nineteenth century town hall that, in its early years, loomed over lesser buildings.

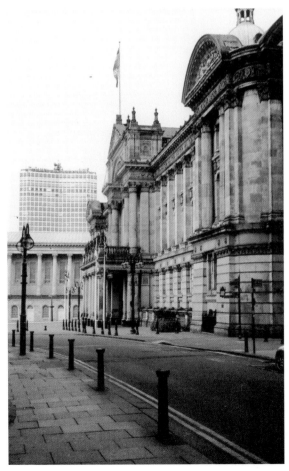

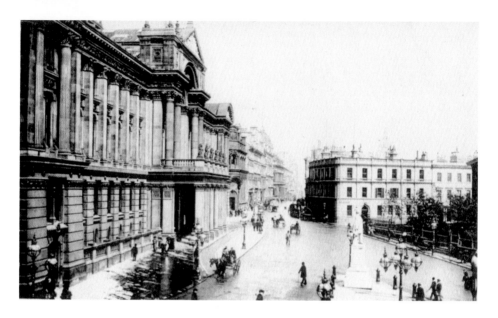

Council House and Colmore Row

This Row, named after a prominent Birmingham family, had earlier borne a series of different names. Across the way can be seen part of the churchyard of Christchurch, which was built in 1805 by public subscription and demolished in 1899, to make way for a group of buildings, dubbed by the public in the 1930s 'Galloway's Corner', after the large chemist-photographer shop on the site. Known officially as Christ Church Buildings, this block of commercial activity was demolished in 1970, enabling a modest amount of ground to be grassed and trees planted.

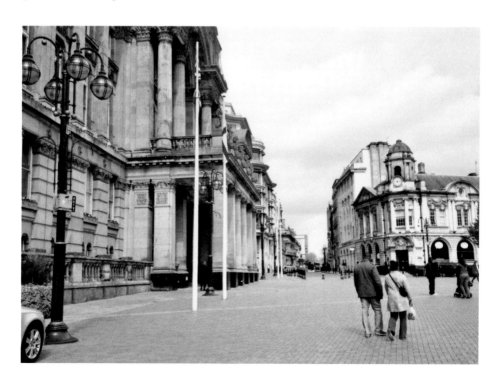

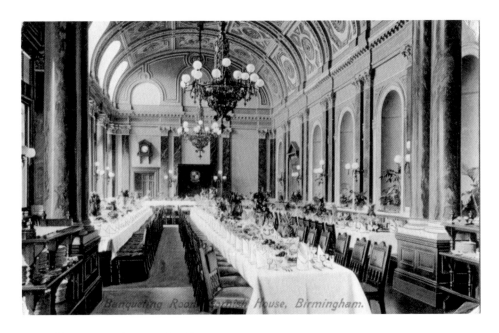

Council House — Banqueting Room

On the first floor of the Council House, reached by the grand staircase, three ornately decorated rooms with elliptical ceilings stand ready for important civic receptions. The postcard is franked 1906, since when the chairs in the banqueting room have obviously been replaced, as no doubt have the carpet, fittings and paintwork. Banquets would be held for a variety of groups including representatives of municipal authorities from abroad, for example, a party from Copenhagen on 2 June 1950. In 2009, it has been made plain, in a very handsome brochure, that the banqueting suite and its facilities, are now available for private hire. (Photograph courtesy of Birmingham Corporation)

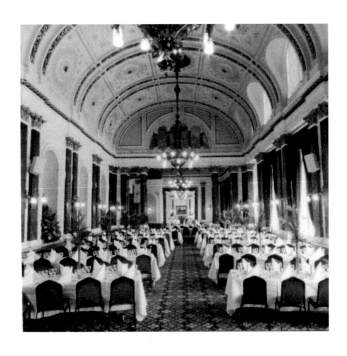

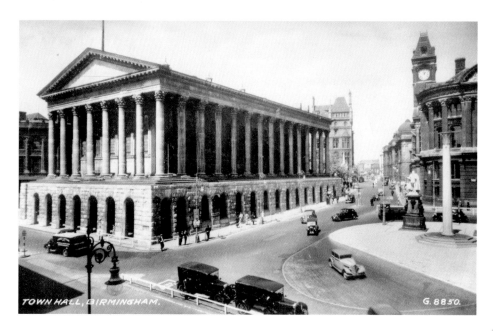

Town Hall

Built of brick and clad with Anglesey marble, the Town Hall was designed by Edward Welch and Joseph Hansom with musical performances in mind, city triennial music festivals having been held in the city since 1784. Before the formal opening, a public celebratory musical festival was held in the hall in 1834. Since then, this historic building has been extensively used for all manner of musical concerts, impassioned political debates and fundraising events. From the postcard, franked 1939, it can be seen that motor traffic is slicing away pedestrian space. Seventy years later, the situation is evidently very different, even if road repairs remain a constant!

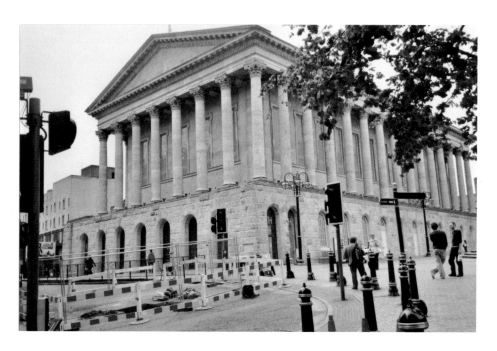

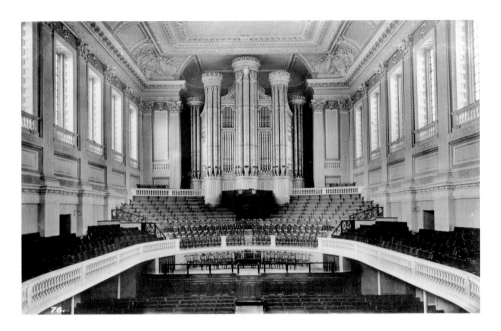

Town Hall — Interior

The building has proved to be a premier concert hall, attracting world-class musicians, including Felix Mendelssohn and Sir John Barbirolli. In 1919, the Council took the bold step of using rate-payers' money to subsidise the formation of the City of Birmingham Orchestra (later CBSO). After a shaky start, the appointment in 1924 of Sir Adrian Boult as conductor brought about considerable improvement. The orchestra went on to greater fame with Sir Simon Rattle as conductor. The Hall itself, after a period of neglect, underwent massive restoration, resulting in the splendid appearance shown below.

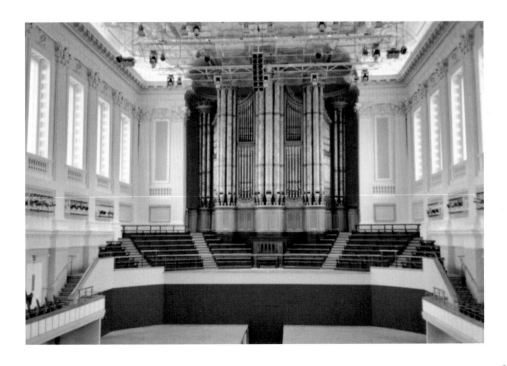

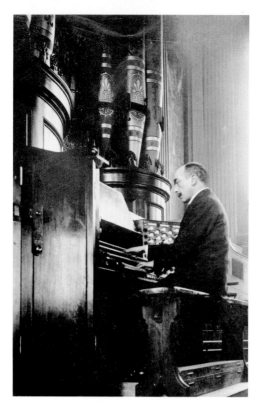

Organ

The creation of a space for an organ
in the hall was a happy afterthought,
the idea not having been included
in the original design. Great success
followed, not least because of the
talents of the organists themselves.
Mr Perkins served in the period 1888-
1923; Mr G. D. Cunningham, 1924-1949;
Sir George Thalben-Ball, 1949-1983,
which is when Mr Thomas Trotter took
over. Regular organ concerts are now
divided between the Town Hall and the
much newer Symphony Hall, opened in
1991 and now home to the CBSO. The
new picture shows the restored 1834
William Hill organ.

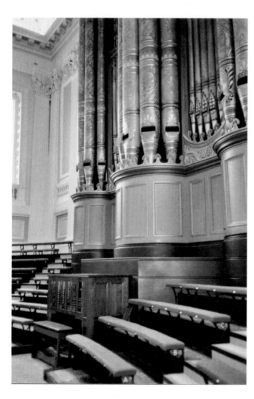

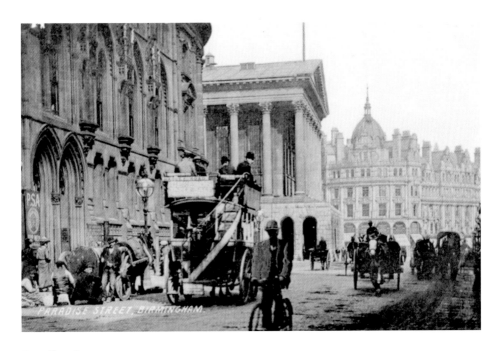

Paradise Street

To the left of the horse bus on its way to New Street can be seen a tar boiler, also horse-drawn. Four road workers, one seated on an upturned bucket, are taking a break outside the Midland Institute. Between that building and the town hall stood Ratcliff Place, where, in their day, hansom cabs could be hired. Now the road shown forms part of Paradise Circus, one of several traffic junctions in the city centre.

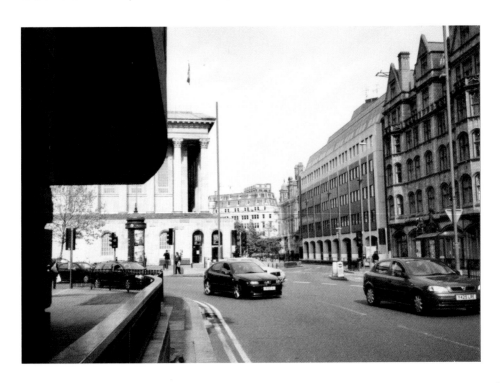

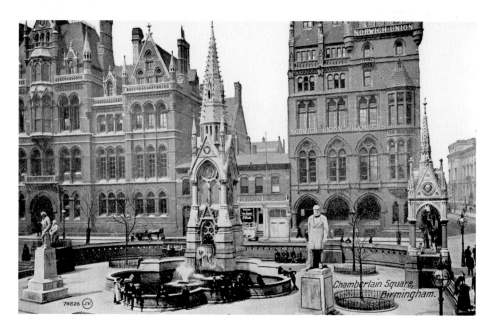

Chamberlain Square

As a backdrop to the memorial stands the university, a 'university restaurant' and an insurance office. A fair bit of clutter, rather favoured by Victorians, surrounds the fountain, erected to honour the city's greatest mayor and M.P., Joseph Chamberlain. Water tends to attract idlers as well as sightseers. This remains the case after the rebuilding of the Square and the restoration of the fountain and a new pool in 1978, with the whole area being far less ornate. But a new statue has appeared, a life-size bronze of Thomas Attwood (seen here sprawling), Birmingham's first M.P. following the Great Reform Act of 1832. The arrival of the street cleaner was fortuitous! To the right stands the art gallery, and behind the fountain is part of the modern central library.

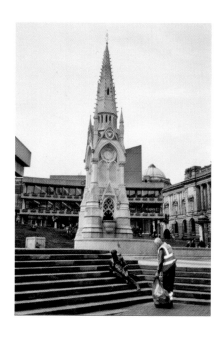

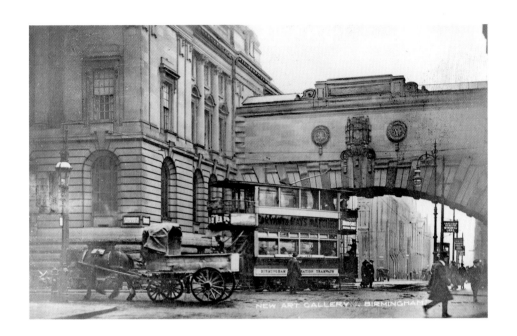

Art Gallery and Extension

The bridge across Edmund Street was built to link the original art gallery to the new extension, on the left, shared with council offices. The tram is turning into Congreve Street, where the horse and cart are also heading. The first of the tram signs reads 'Cars Load Here For Windmill Lane'. To the left is the entrance of the central library, claimed to be the largest leading library in Europe.

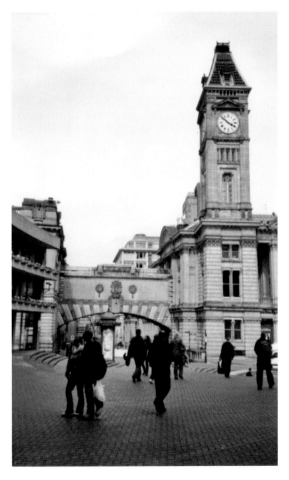

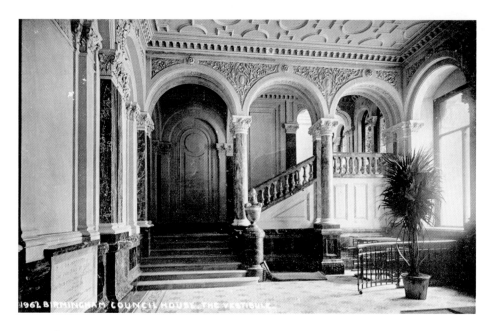

Art Gallery Entrance

Despite the separation of many years, this seems like a Tweedledum and Tweedledee reunion. However, the later picture of this entrance to the art gallery appears lighter, brighter, and more visitor-friendly, and a touch more commercial given the shopping references. Among the exhibitions and events for 2009, many contain a Birmingham theme, including David Cox — Watercolours.

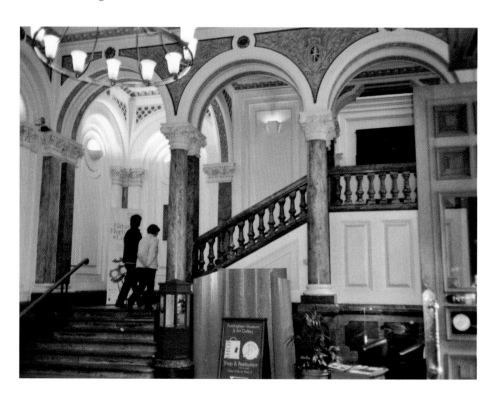

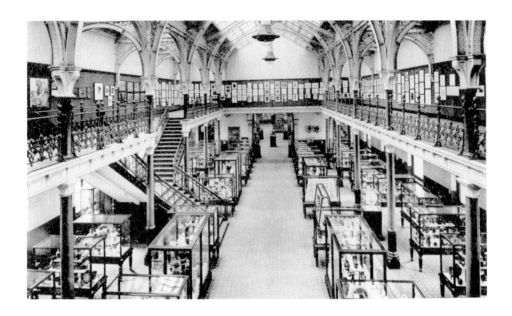

Art Gallery — Interior

No hint of a minimalist approach to display can be found here, then or now. The cabinets are well stocked and walls well bedecked. It is appropriate to recall that the museum and art gallery, built 1884-9, although initiated by the council, was paid for from profits made by the city-owned gas company. Some gifts in the form of paintings and porcelain were made by well-to-do businessmen, a major benefactor being Mr John Feeney who in 1915 bequeathed £50,000, a great deal of money at the time, to the gallery. Some galleries were severely damaged by a 1940 air raid.

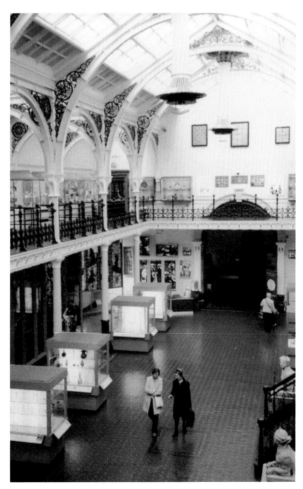

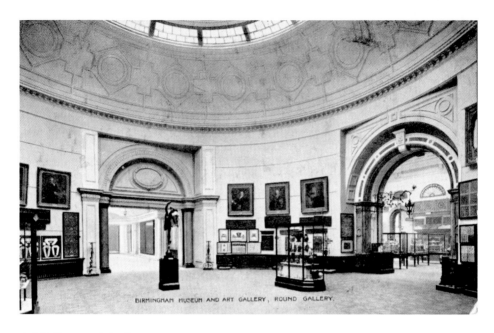

BIRMINGHAM MUSEUM AND ART GALLERY, ROUND GALLERY.

Art Gallery — Interior

On the postcard, the central figure is of Hermes, the Greek counterpart of the Roman Mercury, messenger of the gods, now to be found in the gallery's restaurant. The safe and sedate appear to have been exchanged for the sulphurous and shocking — shocking at least in the 1940s when Lucifer was first exhibited. The sculptor, Jacob Epstein (1880-1959), although born in America, became a British citizen. Much of his work was controversial and thought by some to be indecent and blasphemous. Even so, his undoubted talents were formally recognised by the award of a knighthood in 1954.

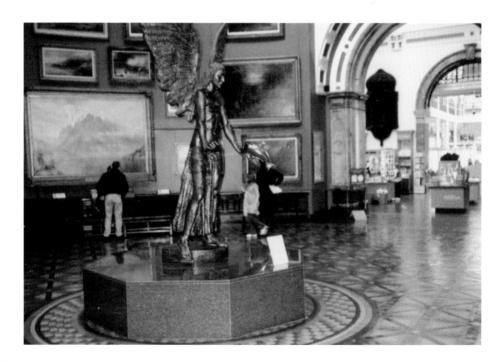

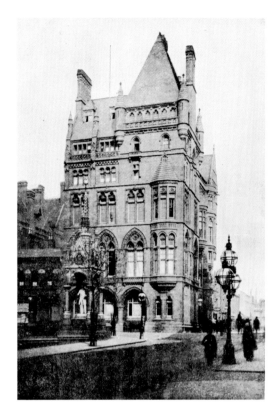

Edmund Street

Returning to the building on the corner of Edmund Street and Congreve Street, the high school girls have left to make way for the Norwich Union insurance company. Then this building itself 'left' to make way for part of the central library, commonplace perhaps in appearance but visually helped by the rows of steps at the entrance.

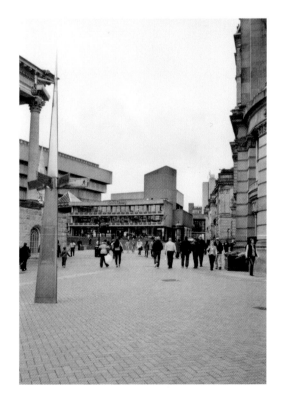

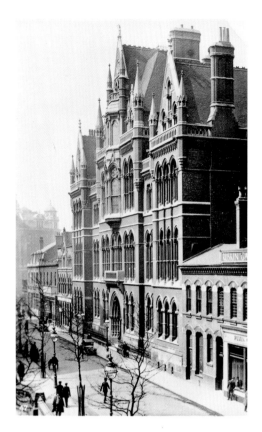

Edmund Street

Founded by a noted Birmingham philanthropist Masons College, opened in 1880, was granted university status in 1900 by Royal Charter. In 1909, a new redbrick university was opened in Edgbaston, but the Edmund Street building remained home to the arts faculty until well after the end of the Second World War. In 1963 the building was demolished to make way for the central library. No-one seems to have a good word to say about the exterior design of this 'beetle-browed slab concrete structure', this alleged example of 'concrete brutalism' which opened in 1973. Apparently, a move is afoot to replace and re-site this unpopular building.

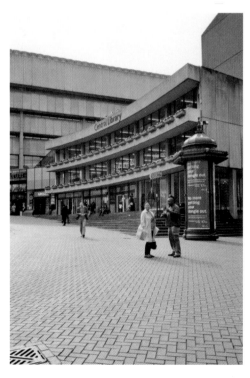

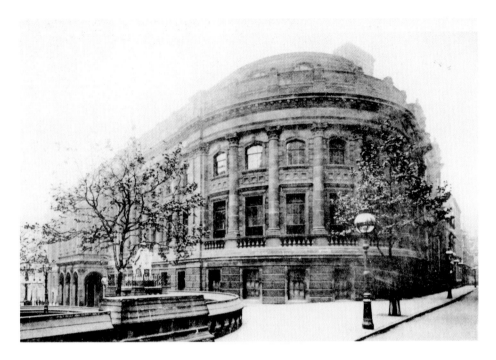

Central Library

Opposite the entrance to Masons College stood the central library with its fine, spacious and airy reference room, a boon and treasure trove to students and research workers. Demolished to create a different form of airy space in Ratcliff Place, we now look towards Paradise Street across a pleasing expanse of brick paving, well-designed steps, a useful handrail and two statues, the nearer being of Joseph Priestley and the other of James Watt.

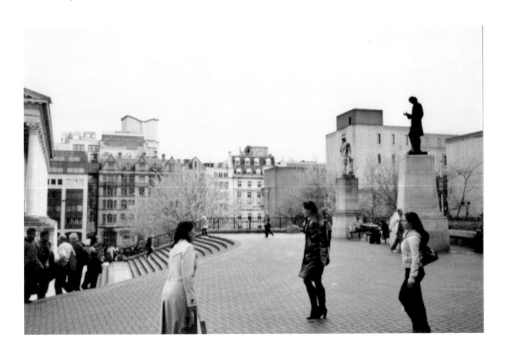

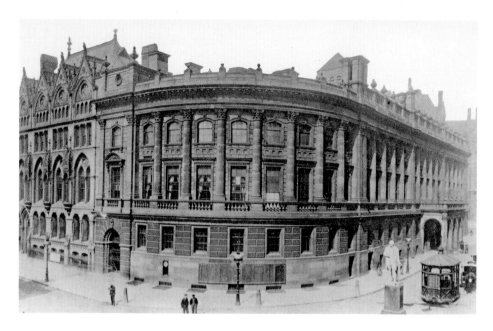

Midland Institute

Developing from an earlier organisation, the Birmingham and Midland Institute opened in 1856. With the backing of the city authorities, the institute zealously promoted adult education, placing great emphasis on the teaching of music. Fronting on to Paradise Street, the Institute side of the building was demolished in 1965 to create space for the Paradise Circus road scheme. Traffic now comes whizzing up to the traffic lights, at green in the picture below. Fortunately, the Institute found another home.

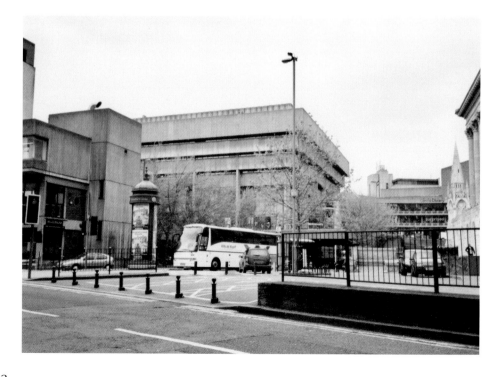

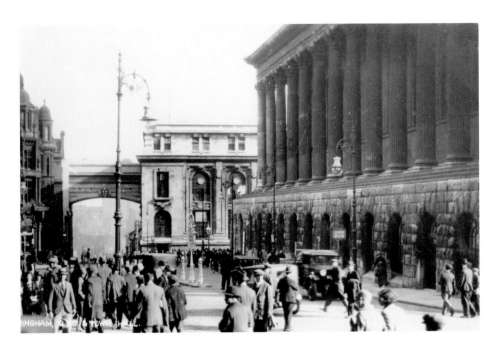

Victoria Square

The postcard shows crowds milling about in Victoria Square, when traffic hazards were relatively few. The grubby and stained exterior of the town hall is all too evident. The bridge linked Birmingham's head post office to the parcels office in Hill Street. The latter office was eventually replaced, functions changed and the bridge removed, as can be seen. In recent years, the town hall has been thoroughly cleaned and this part of Victoria Square fits neatly and in an interesting manner into its adjoining spaces.

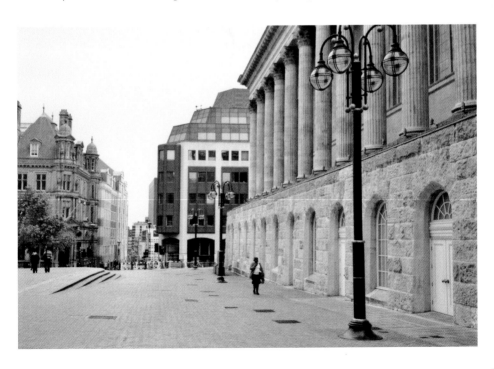

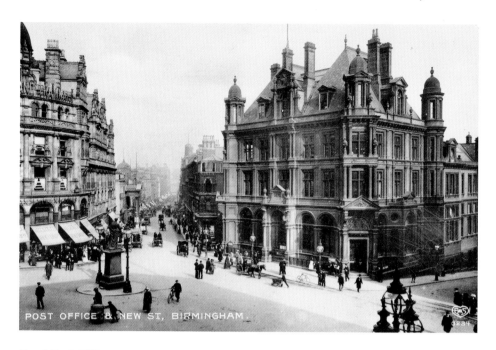

POST OFFICE & NEW ST, BIRMINGHAM

Head Post Office

Thanks to public opposition spearheaded by the Victorian Society when under threat of demolition in 1973, this head post office became one of the city's heritage buildings. Built in a style reminiscent of a French château, this popular landmark dates from 1891. On the left stands the columned portico of the Royal Birmingham Society of Artists Gallery, demolished in 1912, the same year as this postcard was franked. After a good wash and brush-up, the new/old post office looks much more stately, yet at home in its new surroundings.

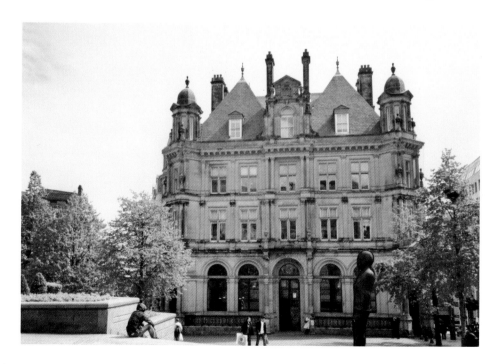

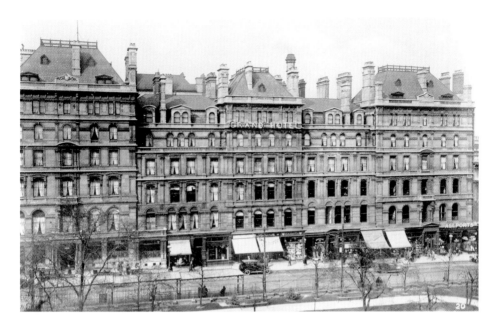

Grand Hotel

In its heyday the Grand lived up to its name, being one of the city's premier hotels: a Victorian building, completed in 1875, on Colmore Row. The postcard view has been taken from just inside the grounds of St Philip's Cathedral. One example of the affluent nature of the hotel can be given here. On 5 March 1931, in the Grosvenor Room, the Twenty-Eighth Annual Dinner of the Coal Trade Benevolent Association (Birmingham Branch) was held, with the sumptuous menu being all in French. What would those diners make of 'Begel' and 'Oddbins'?

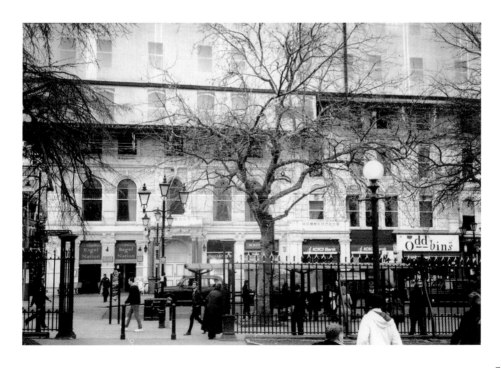

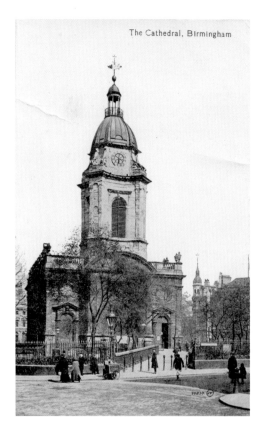

The Cathedral, Birmingham

St Philip's Cathedral
Built in 1716, this Anglican church became a cathedral in 1905. The postcard's message includes; 'Not a very large "Cathedral" FB', seeming to suggest that this is not as grand a cathedral as generally understood. But the reference to size is fair. Ninety years on, the size is still the same, visitors are many and concerts titled 'Music in the Cathedral' have been much enjoyed. Yet more people make good use of the footpaths that criss-cross the churchyard. These public footpaths are also handy as short cut links between the two main railway stations.

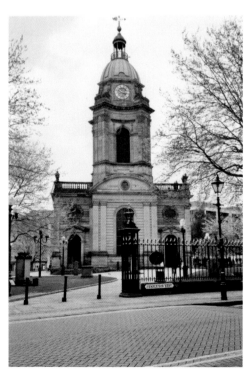

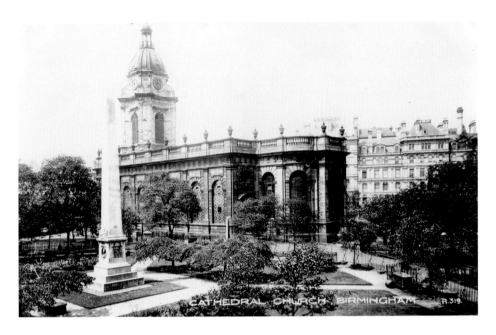

St Philip's Cathedral

This view was taken from Temple Row, with the postcard franked in 1915. The present-day photograph shows that some shrubbery has been removed and sturdy benches set in place to encourage passers-by to rest and reflect. The obelisk carries the inscription 'KHIVA 1875'. Khiva is an ancient city in what is now known as Uzbekistan. Research continues.

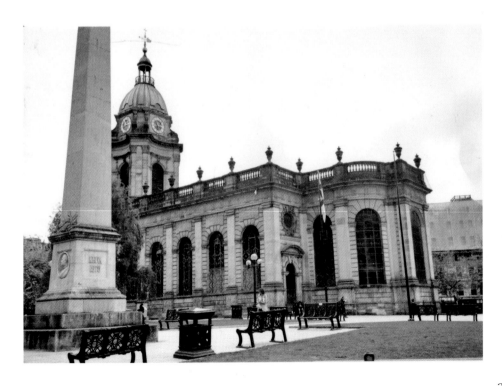

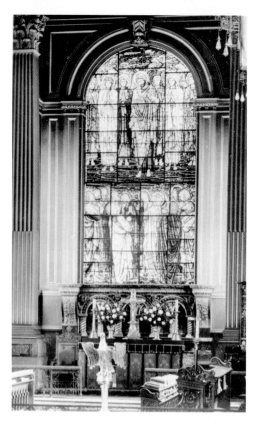

St Philip's Cathedral — Interior

A major attraction for visitors has long been this stained glass window depicting the Ascension designed by Sir Edward Burne-Jones (1833-1898), an artist born in Birmingham who became a leading member of the pre-Raphaelite art movement. His output was considerable, demonstrating particular strength in the fields of both Arthurian and classical legend. Birmingham naturally takes particular pride in this artist's achievements and has a fine collection of his work, which has attracted international acclaim. In his lifetime, Burne-Jones was awarded the Legion d'Honneur by the French.

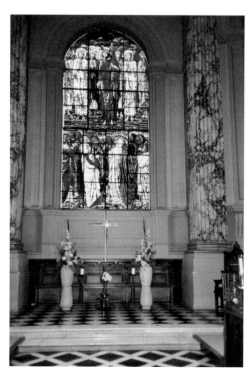

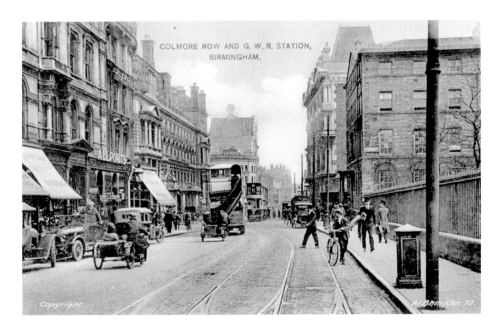

COLMORE ROW AND G. W. R. STATION, BIRMINGHAM.

Colmore Row

A good mix of traffic types creates a bustle of activity and the double-decker bus is of particular interest, not then but now perhaps, its staircase being open to the elements. The GWR station is, of course, Snow Hill, the entrance to which is just beyond and to the left of the No. 9 bus. Nowadays, much of the traffic along Colmore Row consists of buses, which make scant noise as they glide to a halt and re-start without a clash of gears and smelly emissions. Trees, in springtime leaf make a welcome addition to the scene.

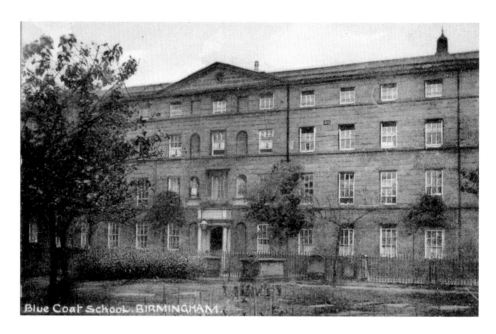

Blue Coat School, BIRMINGHAM.

Blue Coat School

This is a charity school that opened in 1724 adjoining the eastern side of St Philip's cathedral grounds. At the outset, the school roll comprised thirty-two boys and twenty girls. The school's objective was to train youngsters to become apprentices and domestic servants. The building closed in 1930 when the school moved to Harborne. Eventually, the building grew from four to seven storeys. Hopefully, there is now space enough for all the staff of the 'Government Office for the West Midlands', an identification very modestly presented near the doorway.

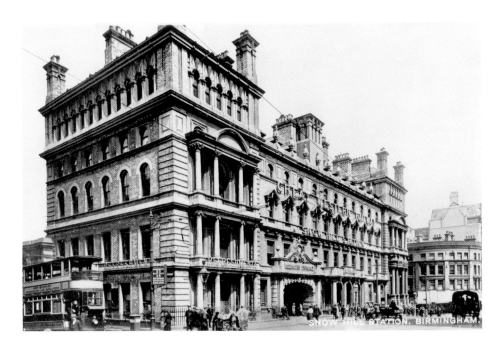

Snow Hill Station

Opened in 1863, this imposing GWR station looks in prime form on the postcard. The West Bromwich tram has reached the top of Livery Street, a street of notable length: according to older Brummies, a grumpy looking person was alleged to have a 'face as long as Livery Street'. At the left-hand corner of the building can be seen a tram designation signboard, 'Handsworth 23 New Inns 28 West Bromwich'. Livery Street now enjoys different company, and, while a spring shower has opened umbrellas, it has not produced long faces.

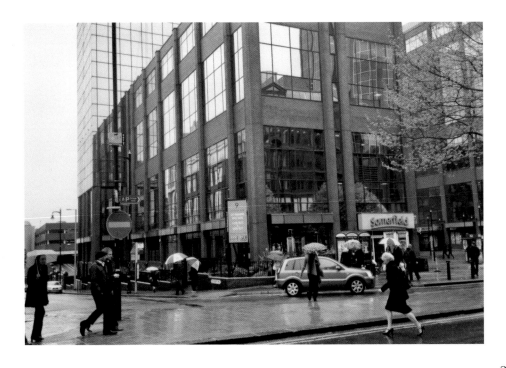

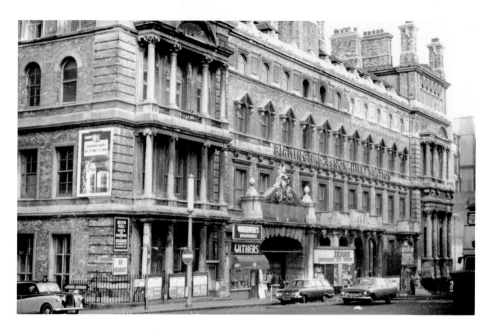

Snow Hill Station

Above is a photograph from the post-Second World War period, when the national railway system was in serious decline. Inevitably perhaps, the once self-confident Victorian building suffered badly from serious neglect, as shown. 'Withers' seems an ironically appropriate name for the situation. In 1969, demolition of the hotel began but for some years 'Snow Hill Station Buildings remained a gaunt black decaying citadel amidst the vast concrete jungle of the new Birmingham'. Fresh investment and fresh life have now returned in good measure to this railway station area.

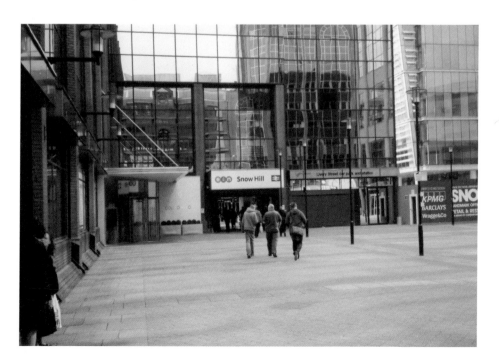

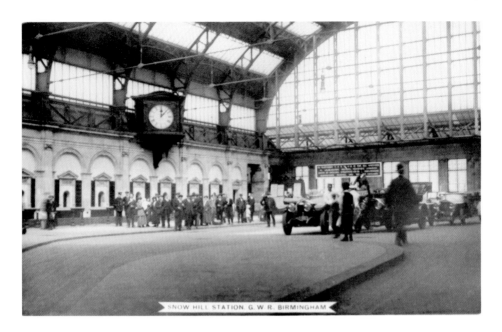

SNOW HILL STATION. G. W. R. BIRMINGHAM

Snow Hill Station

'Meet you under the clock at Snow Hill Station at...' This was a popular spot for a rendezvous. The impressive booking hall was roofed by a single-span arch. Having passed through the station hotel's access tunnel, would-be train passengers would emerge into this airy space with its row of dignified, sculptured-like ticket stands. The new booking office lies further into the passageway, and, while no doubt fit for purpose, it seems commonplace and lacking in a touch of grandeur conveyed by the Victorian counterpart.

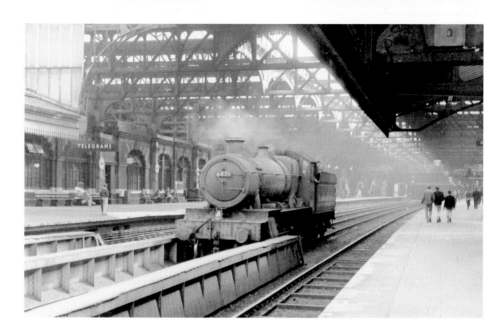

Snow Hill Station

This fine station was opened in 1852. This popular GWR station was the one to make for when holidaying in Devon or Cornwall during the inter-war years. Just before the outbreak of war on 3 September 1939, the station witnessed the mass evacuation of Birmingham children to safer parts of the country — operation Pied Piper. After being closed in 1972 the station came to life again in 1987. Compared to the 'romance of steam' days, the station's network is now diminutive, but the danger of getting grit in the eye has also gone.

Great Western Arcade

This not-very-successfully tinted and touched up postcard was posted on 8 December 1906 so, given its age, the picture's slight lack of realism can be forgiven. The arcade's high arched entrance lies directly opposite the entrance of old Snow Hill Station — and the new. Incidentally, the tram appears to be running on three rails. The centre rail is, in fact, a narrow duct along which a steel cable moves continuously and to which the tram can be gripped and released as required. A cable tram service worked for some years from Colmore Row to Hockley Brook, and later to Handsworth. Given the proximity of the arcade, modern shoppers, like those of earlier generations, are unlikely to be deterred by a 'spot of rain'.

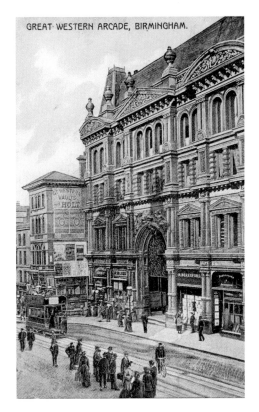

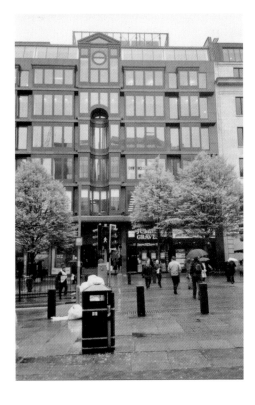

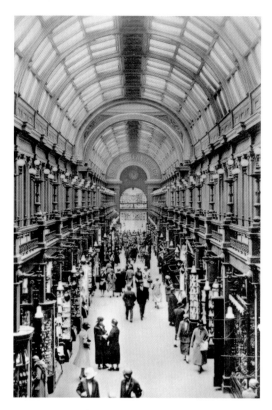

Great Western Arcade

Looking towards Temple Row, this arcade was built in 1875-6 running directly above a railway tunnel. The Great Western was one of several arcades in the city, some of which have disappeared. Arcades were popular with 'real' shoppers and idling window-shoppers alike. As intimated, they could be used as shelters from unkind weather, and as short-cuts from one city street to another. For the most part, arcade shops tended to be of the high-quality goods kind. Changing times bring changing signs, 'pasta' and 'digital' for instance.

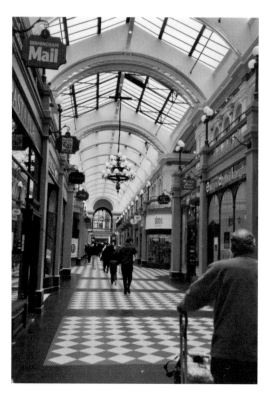

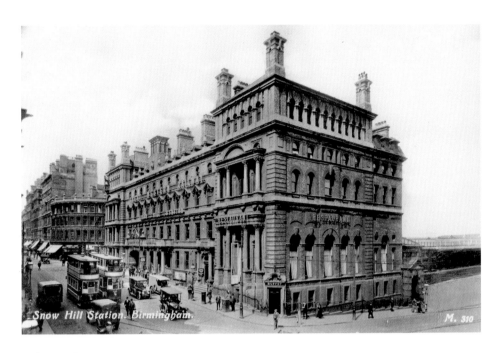

Colmore Row

To the left runs Colmore Row and, to the right, Snow Hill drops away, with part of the station visible. At the corner of the hotel even the buffet entrance carries an air of dignity. 'Delivery' sums up the purpose of much of the motor traffic, namely the transport of goods and people. To the right of the bus is the entrance to Livery Street, so-named because of its association with horses, horse-drawn railway carts and wagons.

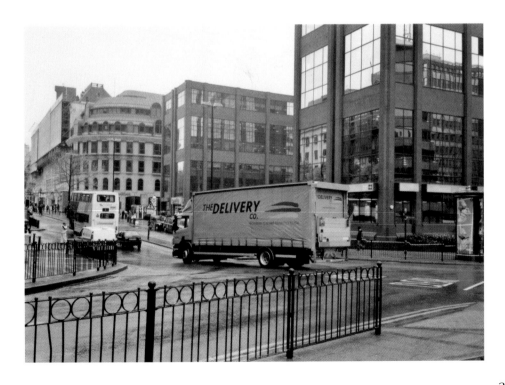

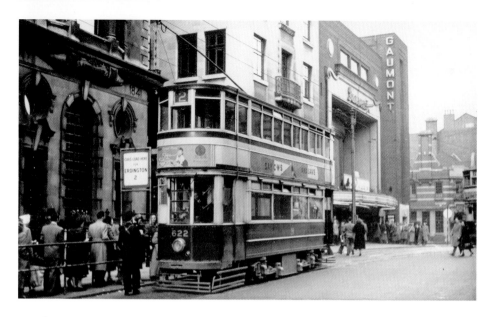

Steelhouse Lane

Although the above photograph is only half the age of some of the illustrations in this book, it is still more than fifty years old, as tram services did not finish until 1953. The tram is at its city terminus in Steelhouse Lane, close to the head office of the Wesleyan General Insurance Company. 'It is not too much to claim that the Gaumont Palace was Birmingham's favourite cinema' (Clegg). This 'palace of dreams' opened in 1931 and closed in 1983. Redevelopment brought to an end the first part of Steelhouse Lane, replaced by new buildings, pathways and pleasing, extensive beds of shrubs as shown. The lower part of Steelhouse Lane is visible behind the tree but, to reach it, part of the Colmore Circus road system must first be circumspectly negotiated.

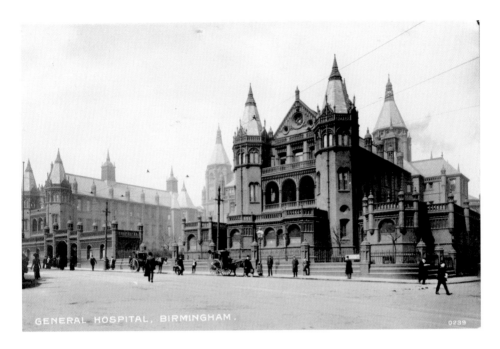

GENERAL HOSPITAL, BIRMINGHAM.

General Hospital

At the lower end of Steelhouse Lane, this hospital was built on the site of an earlier hospital dating from 1779. This new General Hospital, with beds for 340 patients, opened in 1897. All too soon, its bold, cheerful red bricks became soot-begrimed in the city's industrial atmosphere. In its heyday, 'The General' was regarded as the city's flagship hospital. It is now the Birmingham Children's Hospital (NHS).

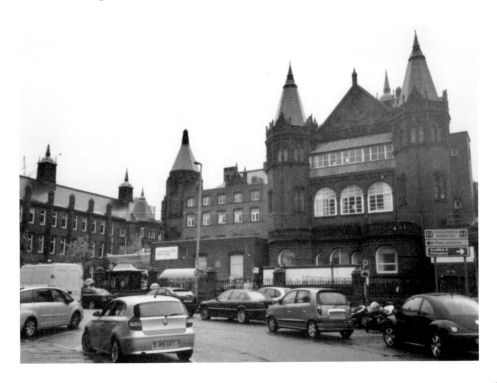

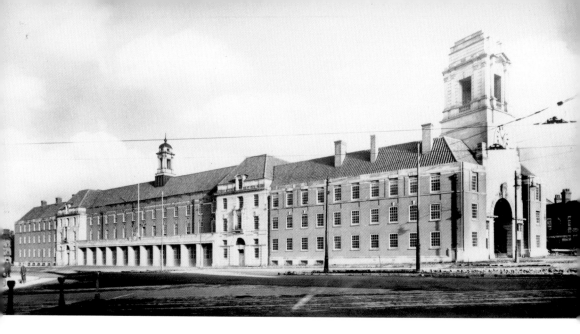

Central Fire Station

In the late 1930s, this modern station was opened for business which soon included tackling the fires and damage caused by air raids, many of them in 1940-1. The station is lodged between Aston Street and Corporation Street on an arc of what used to be Lancaster Place which, with widened roads and a flyover, has become Lancaster Circus. The new, carefully designed interlacing pathways and grassed areas, though quite attractive in themselves, can be a tad challenging to a photographer trying to match 'now' with 'then'.

Aston Street

Above can be seen, several trams at one of the biggest tram junctions in the city, Lancaster Place. The fire-station building runs as far as the white-fronted building. The station is now closed with other uses being found for the building. On the opposite side of the road, changes have been radical and far-reaching in their consequences. Behind the green trees stretches a large part of the forty acre campus of the University of Aston, with more than 8,000 students. Nearby is the Matthew Boulton College.

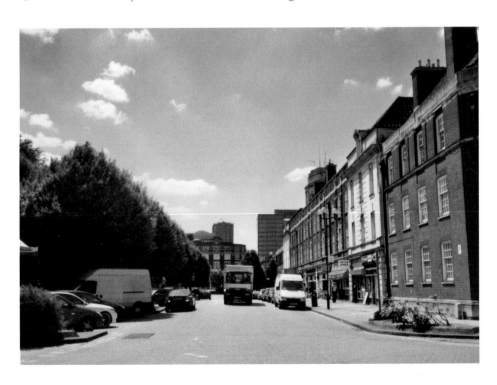

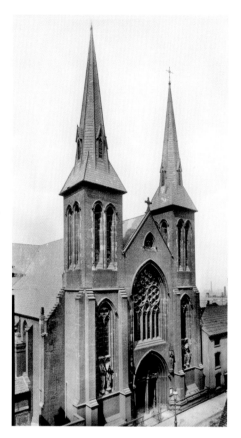

St Chad's Cathedral

St Chad's was the first Roman Catholic cathedral to be built in England since the Reformation. Augustus Welby Pugin (1812-52) designed the cathedral, a young architect who designed and modelled a large part of the decorations and sculpture for the new Houses of Parliament (1836-7) This cathedral, dating back to 1839, is built of red brick in what has been called the Baltic German style. The roof is made of slate. This Victorian building houses a sixteenth-century pulpit. The church now stands on what is virtually a traffic island, at a busy crossroads.

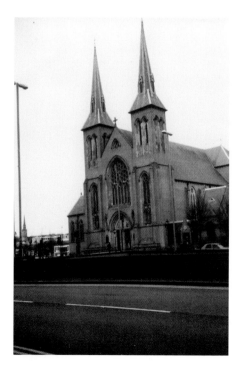

Central Hall

Built in 1903 as the Birmingham headquarters of the Methodist Church, this fine red brick building received the following praise from the distinguished expert on architectural matters, Sir Nikolaus Pevsner: ' ...a tall slender central tower, which forms a splendid landmark in the gently curving street ...' The main hall was on the first floor, sufficiently grand for the authors' grammar school to hold its annual speech day, when wise words were spoken to influence schoolboy behaviour and achievement, and prizes awarded. Modesty forbids...

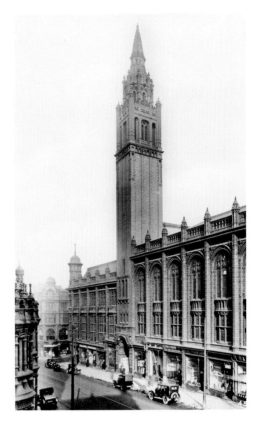

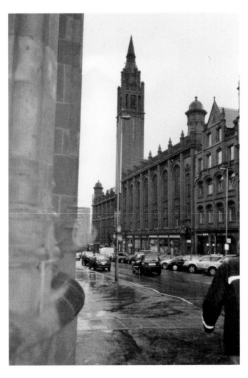

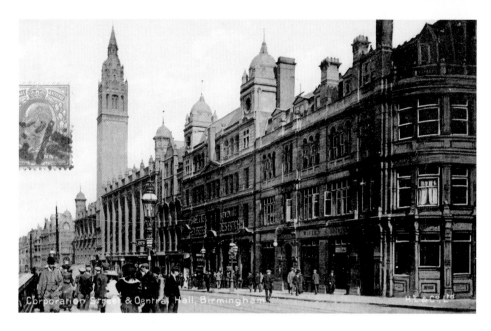

Corporation Street

On the right, and adjoining the church, the building with a pair of similar turrets was once the headquarters of the *Daily Argus*, advertising on a 1901 invoice that 'Sale Exceeds 65,000 Copies Daily', thus making the *Argus* 'The Most Widely Circulated Paper in the Midlands.' In exterior appearance, this entire building block seems to have changed remarkably little. The corner with James Watt Street no longer houses a pub and a fair amount of property seems to be 'to let'. Among the signs, 'New Road Layout Ahead' seems apt for the times.

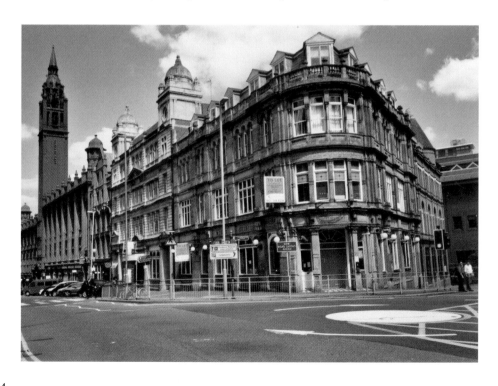

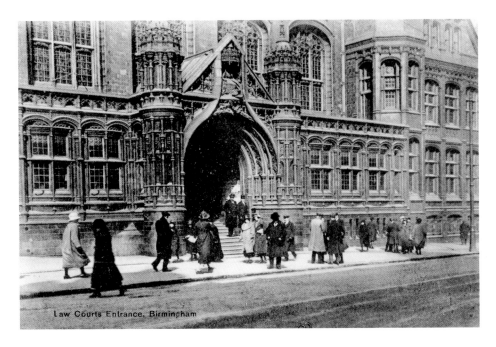

Law Courts Entrance, Birmingham

Victoria Law Courts

Located in Corporation Street are Birmingham's Victoria Law Courts. The queen herself laid the foundation stone for this suitably magisterial-looking building. Built in French Renaissance style between 1887-91, this fine red terracotta structure has become one of the city's designated heritage buildings. A clear view of the entrance could not be obtained because of that ubiquitous white van!

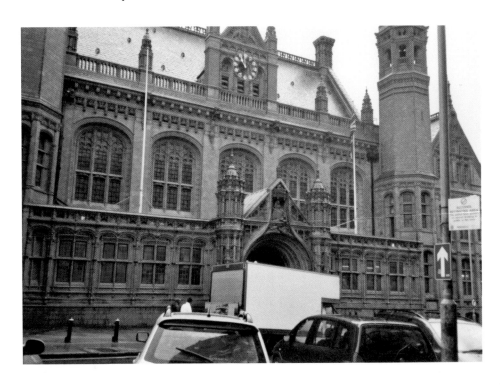

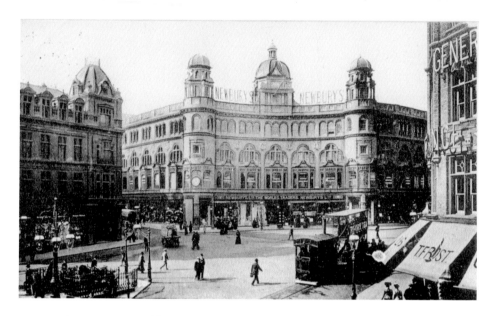

Corporation Street — Old Square

This is one of the oldest scenes in the book. Across the way above the line of shops can be read; 'Newburys Ltd. — The World's Traders — Newburys Ltd', clearly a member of the school of 'If you've got it, flaunt it!' The railed-off area shields the entrance to the below-ground public conveniences. Now, new and lower railings encourage people to cross at safer places as traffic nips around the Old Square's island of greenery. The curved sides of the two buildings — left relatively old, right much more recent — balance each other quite nicely and harmonise well with the far end of the island. Newburys was taken over by Lewis's, who rebuilt their own earlier store to provide the building on the left, which they have since vacated.

Corporation Street

With a Corporation bus turning into
Bull Street, flags are waving atop Lewis's
store. Being a go-ahead store in the
1930s, Lewis's persistently maintained
that it constituted 'over 200 shops in
one', for in addition to goods of every
kind, services could be bought — tickets
for the theatre or travel, hairdressing,
refreshments in the Oak Room, Palm
Court and Ranelagh Room — with an
orchestra to boot, and Jan Berenska
as conductor of light music, including
Cavatina in the repertoire. Just in front
of the tram on the postcard stands a
white-helmeted traffic policeman, now
replaced by traffic lights and far more
spacious pavements. The corner shown,
at ground level, provides the entrance to
a very extensive and popular bar serving
food as well as drink. Smokers have to
puff away on the pavement.

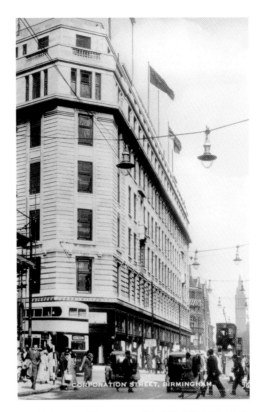

47

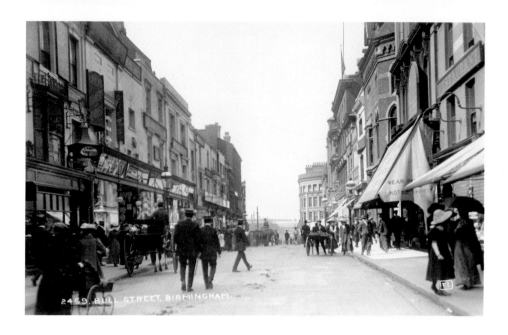

2459. BULL STREET, BIRMINGHAM.

Bull Street

The postcard presents an ordinary, everyday street scene before World War One. Traffic is light and only of a horse-drawn kind. People stroll unconcernedly in the street. An example of the, at this time, seemingly ubiquitous handcart can be seen. The ladies, nearer the camera, could be studying menus of the restaurant, signed above their heads. In the distance, the road drops down to become Snow Hill. Handcarts have now long gone. Is it a bus or a mobile hoarding advertisement that we see ahead? Stops and shelters for a number of bus services are to be found in Bull Street.

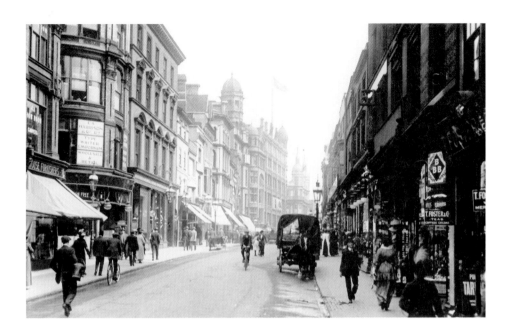

Bull Street

Looking back towards Lewis's, with its flag flying, this is a scene from early in the last century. There are plenty of shop signs that repay close scrutiny. Bull Street has housed some notable citizens in its time: William Hutton, distinguished local historian and bookseller occupied No. 6 and at No. 9, John Cadbury opened a shop for tea, coffee and a steadily growing cocoa based business, the green shoot of what became a foodstuffs commercial empire.

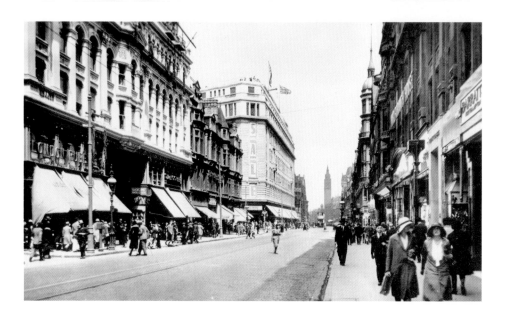

Corporation Street

Back in Corporation Street, the postcard scene probably dates from the late 1920s, a period when ladies' bell-like cloche hats were in vogue. On the left, in the shadowed space between the two lines of blinds, is the probable exit/entrance of the North Western Arcade, an extension of the Great Western Arcade in Colmore Row. For many years, blinds were extensively used by shopkeepers, city and suburban, to shade and protect their wares from the sun and those pausing outside from the rain. With refrigeration and air-conditioning now widely available, blinds are seldom needed. Some city shops still provide overhangs to protect shoppers from bad weather. The distinctive angular corner of the former Lewis's store and that 'slender tower' can still be seen behind the fresh green leaves of the trees. The bus is bound for the Black Country, note the sign — the territory of erstwhile Enoch and Eli, and their humorous tales.

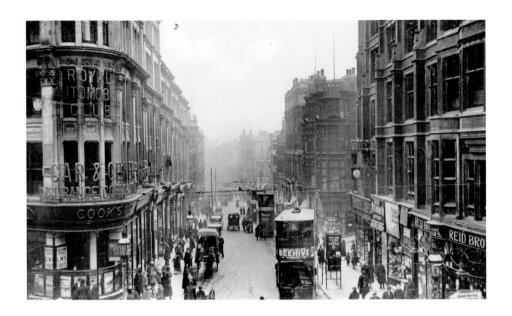

Corporation Street — Martineau Street

A little further along the eastern side of Corporation Street ran the above street, where an important tram terminus for several routes was located. The No. 6 service ran to Perry Barr. The advertised Beehive was a store popular with working-class mothers. Reid Bros. was a quality gentlemens' outfitters. On the opposite corner a variety of signs reflect the growing interest of the public in travel and some of the organisations involved. Returning to 2009, it is a little hard, even a touch eerie, for former tram travellers to accept that Martineau Street has vanished in the redevelopment of an area, now bounded by sections of Corporation, Bull, High and Union Streets to become Martineau Place, the family of that name having been among the 'movers and shakers' of an earlier Birmingham.

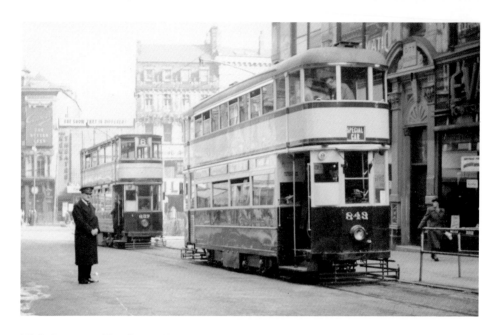

High Street — Martineau Street

A small nugget of social history stands behind the service No. 6 tram waiting to move to its terminus in Martineau Street. Located on the High Street, the lowest, reasonably new-looking building is the News Theatre, a cinema in fact, and the first of its kind in the provinces, opening in 1932. The early photograph, dating from 1948, shows tramcar 843, the last tram Birmingham bought, of latest design and light in weight being constructed of aluminium. The 2009 photograph, taken from a High Street viewpoint shows what can happen to concrete slabs.

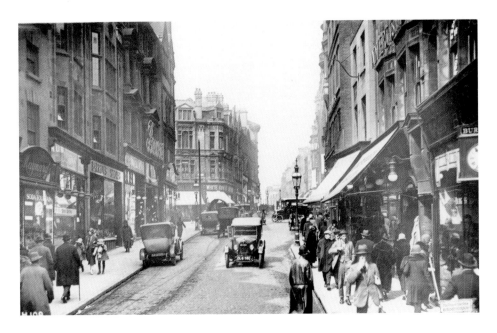

Bull Street

A typical city centre scene from between the wars is shown on the postcard. One of the contrasts with today is the wearing of headgear. A variety of hats is worn by the men, the type of hat often serving as a pointer to the social class of its wearer. Most, but not all of the cars have pneumatic tyres. American influences are beginning to appear — note left, 'Soda Fountain.' Such influences have become pervasive: witness KFC on the photo below, where there is also a reference to Martineau Place. New street facilities include litter bins, bus shelters, benches, and advertising columns, but trees are soothing to the eye.

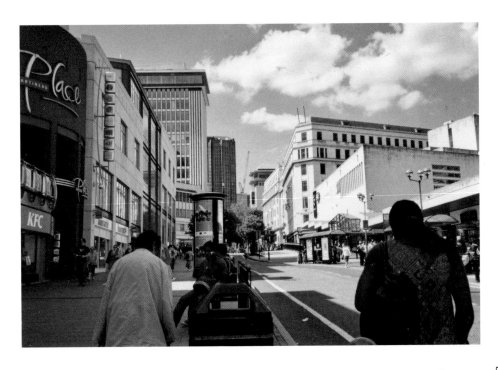

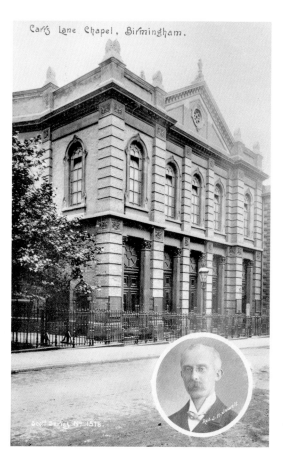

Carr's Lane Chapel, Birmingham.

Carr's Lane Chapel

Nonconformist churches and chapels enjoyed a strong following in Birmingham during the first half of the last century. Carr's Lane Chapel constituted the Congregational Church's headquarters in the city. Dr Jowett was the pastor here 1895-1911. That chapel was demolished and on the site appeared a car park and a small grassed playground. As the replacement church was built close by, it seemed reasonable to include the photo below, not least because of the highly dramatic break the new church makes with the past, from the ornate and orthodox Victorian, to the simple, no-frills Scandinavian?

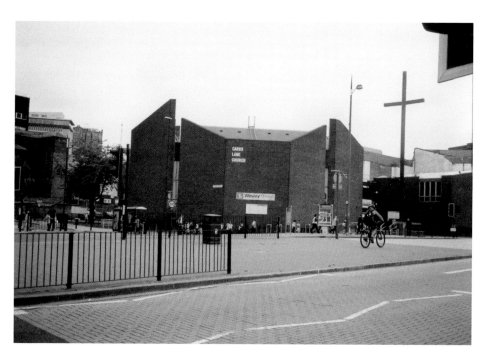

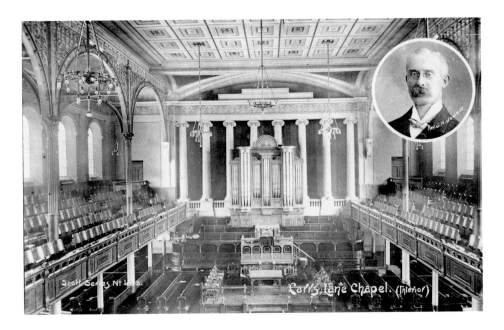

Carr's Lane Chapel

It can readily be imagined how moving music and mass singing must have sounded in this splendid, symmetrical, spacious hall. The card was posted in Aston Manor, Birmingham. Aston, with other districts, formally became part of the city in 1911. Dr Jowett eventually moved to the Fifth Avenue Presbyterian Church, New York. Radical change also marks the design of the new interior — light, clean, simple and reflecting a readiness to move with the times — note the screen.

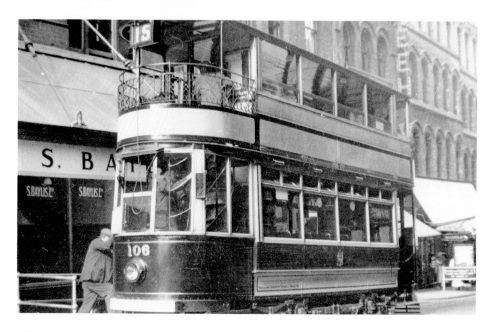

Albert Street

Although an unpretentious thoroughfare, certainly lacking in glamour for shoppers, Albert Street has a long association with transport, both public and private. In 1884, a tram service, operated by the City of Birmingham Tramways Co. ran between Albert Street and Nechells: about a two mile slow and sedate journey, the tram being hauled by a pair of horses. Later, Albert Street served as a city centre terminus for electric tram services. Now it forms part of an important central car park, but the car shown is exiting from an adjacent street.

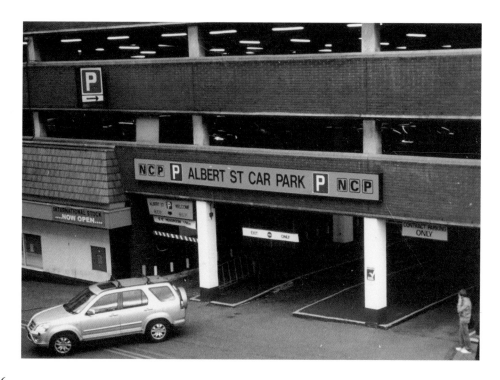

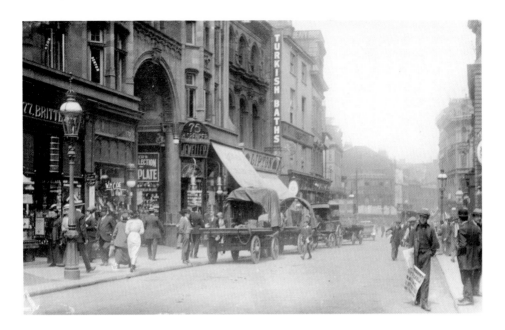

High Street

Back on the High Street, the postcard's sender writes: 'This is a side street in the business part of Brummagem. The opening on the left leads into a big arcade' (Midland Arcade). Turkish Baths were in vogue — for some! The later view looks towards Dale End with plenty of space for pedestrians, a large branch of Boot's the Chemists on the left, with an overhang offering little presumed cover. Turning around we move into the part of High Street that drops down into the Bullring area.

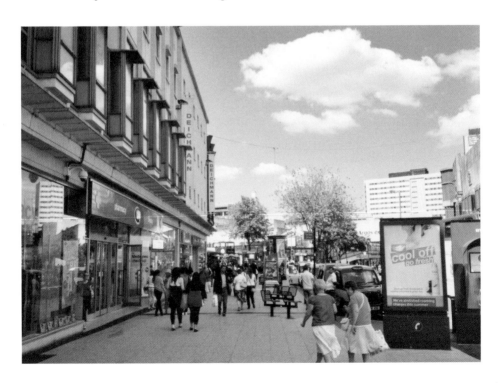

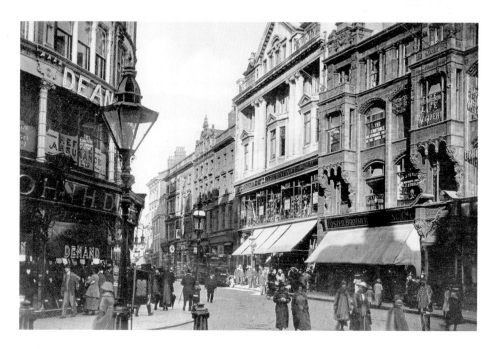

High Street — New Street

The postcard shows the corner of New Street and High Street with the latter continuing right, into the Bullring. The modern High Street retains its shopping tradition but, self-evidently, much has changed, not least the appearance of a flower stall, by no means the only one in the city centre streets. More exotic blooms than in the past are readily available, but it might be harder to find the equivalent of a penny bunch of violets, or to hear "to tek 'ome to the missis..."

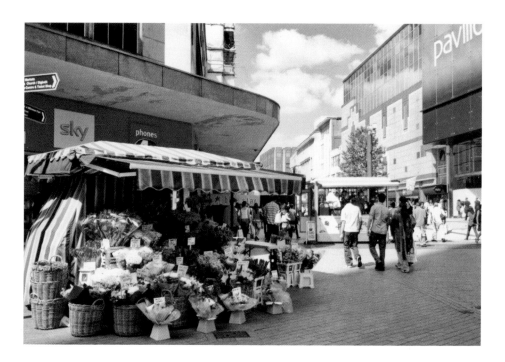

The Bullring

Over the years, the Bullring has changed so radically that it is difficult to identify where 'once was' now is. Even using the statue of Nelson as a reference point is open to error, for the postcard Nelson, just right of the awning 'Child & Co' has, in the tumult of change, been moved from his long- established station among the street stalls to a captain on the bridge position, with a rail nearby. Looking towards St Martin's church, a gap has opened up to the right of the building. Other 'losses' have occurred: it is no longer possible to buy market hall bread dipped in meat dripping — scrumptious! Now, it's more a question of a cappuccino at a nearby café, in continental style.

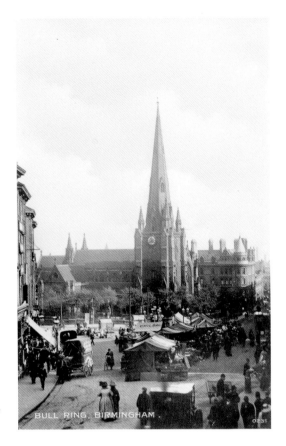

BULL RING, BIRMINGHAM.

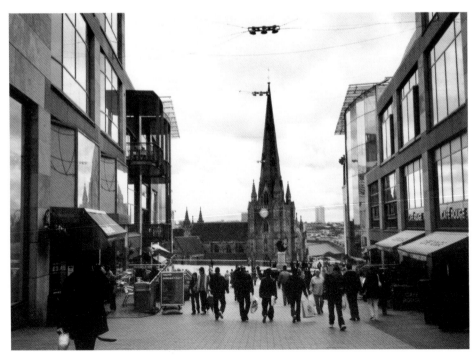

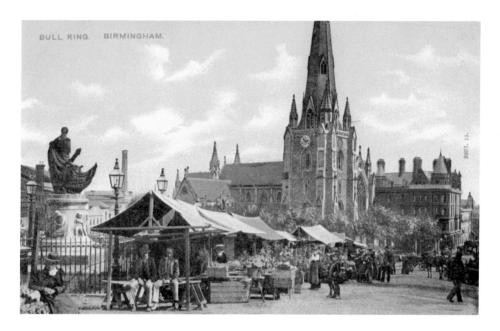

Bullring

Given that Birmingham was as far from the coast as any town could be, it was greatly to the credit of its citizens that by public subscription the statue of Nelson was the first in the country to so honour the great sailor. On his port side looms part of Selfridges, opened in 2003. On any measure, the building might be judged to be unorthodox in design, but the store has been a great commercial success. Because of its 15,000 circular 'scales' of aluminium, the building has acquired the name of 'Armadillo'.

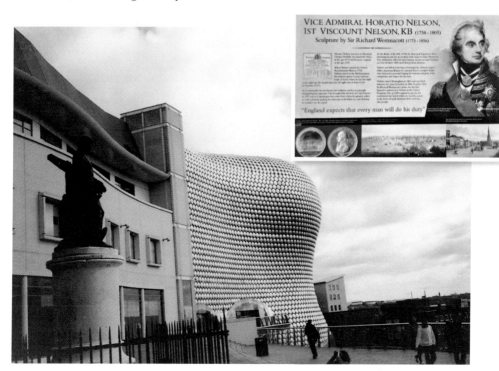

St Martin's Church

A succession of churches has stood on the site now occupied by St Martin's, the Birmingham parish church. The building shown was consecrated in 1875. It would seem a pity to leave the Bullring without acknowledging the memorial to air raid victims killed during the Second World War. Although memories will fade with succeeding generations, many of those who experienced that war can still feel poignant emotions at the memorial.
A name is recognised and a visitor murmurs; 'one day he came to school and the next day, he didn't'. 77 air raids resulted in 2,241 killed.

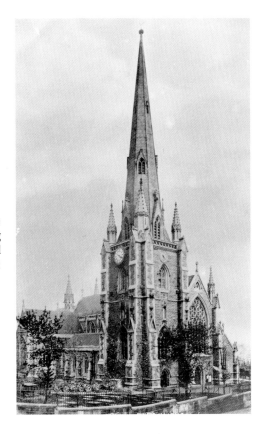

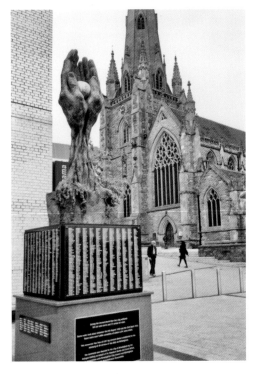

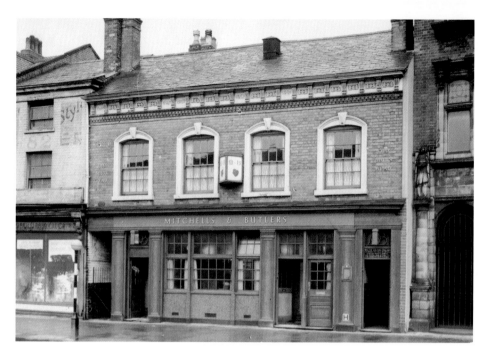

A Digbeth Pub

For older Birmingham people, Digbeth conjures up images of large markets: retail and wholesale, meat, fruit and veg, and the popular Rag Market. When markets were, by necessity, more labour intensive than they are today, thirsty market porters, were well catered for by local pubs. After the Second World War, many Irish people found work in the city and settled in the neighbourhood, with Digbeth becoming known as the Irish Quarter. The two photos reflect something of that change. The Old Bull's Head, above, has become the Kerry Man, fronted by the seemingly inevitable dual carriageway.

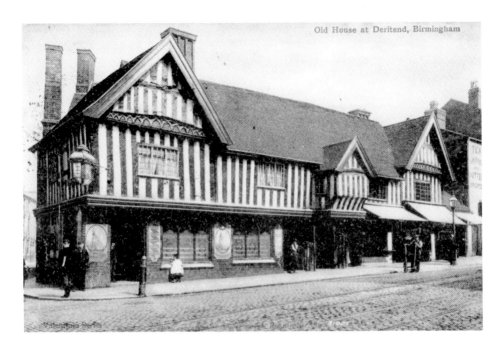

A Deritend Pub

With fourteenth-century origins, much of the Old Crown Inn is thought to date from the sixteenth century. A half-timbered building in an industrial city is something of a rarity, hence the interest shown in the inn is considerable. Extensive restoration work has been carried out, the exterior appearance remaining much the same, and the interior modern facilities are listed on a rather sorry-looking banner at first floor level. Any second, traffic will be zooming past where trams once worked rather more sedately. Tram lines can be seen on the postcard.

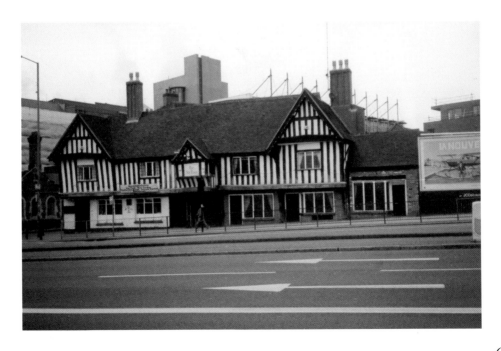

63

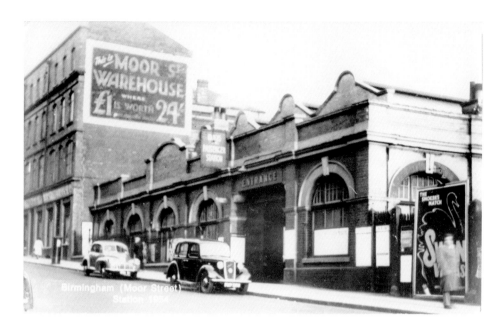

Moor Street Station

By railway station standards, Moor Street is relatively new, having been opened in 1909 for 'God's Wonderful Railway' (GWR — Great Western Railway) to assist Snow Hill Station. For those unfamiliar with old money, there were twenty shillings to the pound, so, on the face of it, four bob, i.e. twenty per cent was not to be sniffed at. That sales approach has been maintained, with the blue banner reading 'Moor affordable'. Refurbished at a considerable cost a few years ago, the station is now a Grade II listed building. A fitting canopy has been added.

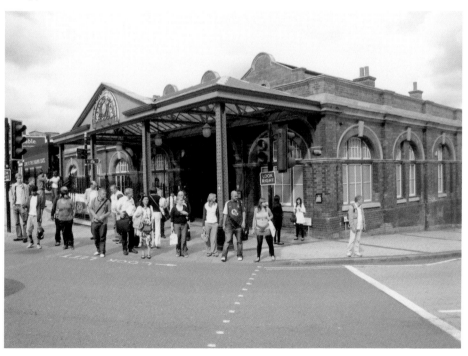

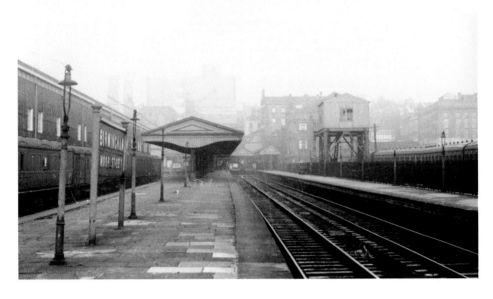

Moor Street Station

The earlier photo dates from late September 1950, 'Season of mists...', commonplace murk, or just a grey day? Weather conditions seem just the same in 2009, as does the restored platform and its shelter. What is mildly surprising is the sight of weeds, given the amount of money spent on refurbishment. The greatest change, as elsewhere, lies in the nearby environment. A large part of Selfridges store is on display along with the Rotunda, a futuristic building now forty-five years old. No doubt the motorist-cum-shopper gives a sigh of relief at the sight of that letter P.

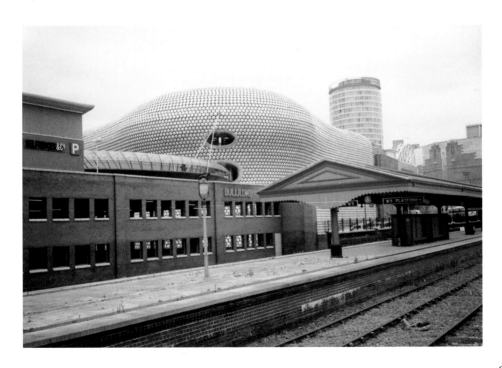

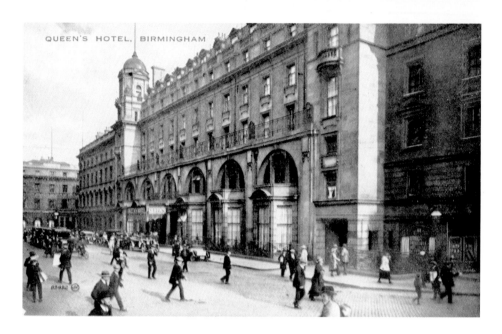

QUEEN'S HOTEL, BIRMINGHAM

New Street Station

In 1854, the Queen's Hotel and the newly finished New Street Railway Station were opened, with the hotel fronting the station. To provide more accommodation, the hotel was enlarged in 1911 to appear as it does on the postcard. As part of the latest redevelopment of the railway station, the hotel was demolished, and a shopping centre, the Pallasades, was built above the station. Entrance to its platforms is reached by shop lined, maze-like corridors. But space has been left for parking, bus services, and, as shown, possible recruits into the armed forces.

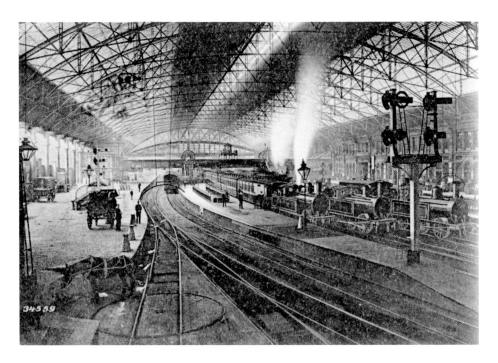

New Street Station

Opened in 1854 and virtually doubled in size some thirty years later, the station was covered by a vast iron and glass roof of impressive proportions. That airy vault has been replaced by a seven acre slab of concrete serving as a ceiling for the multitudes of passengers who step on and off trains in artificial light. It is impossible to take a panoramic view of the platforms as these are largely cased-in, like long corridors. Even so, the station copes with well over 1,000 trains a day. However, it is widely acknowledged that a new station is needed.

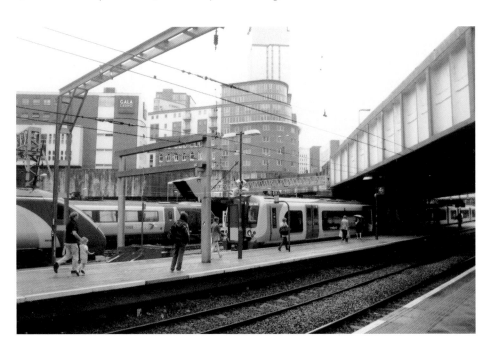

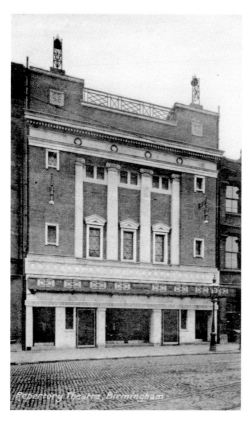

The Old Repertory Theatre

The name rightly associated with this theatre is Sir Barry Jackson (1879-1961), who founded the theatre in 1913 and who, in the opinion of many theatregoers, developed it into the leading British Rep. It is interesting to recall that, during the Second World War, theatre programmes carried this type of message; 'Air Raids — Patrons will be informed when an 'alert' signal is given. Keep calm, the performance will go on. You are safer here than in the street. If you wish to leave, please do so quietly'. Clearly, a fine effort has been made to keep an old and cherished theatre, 'alive' in Station Street. The new Repertory Theatre stands in Centenary Square.

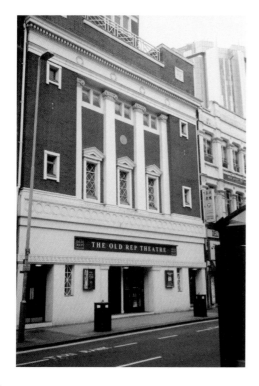

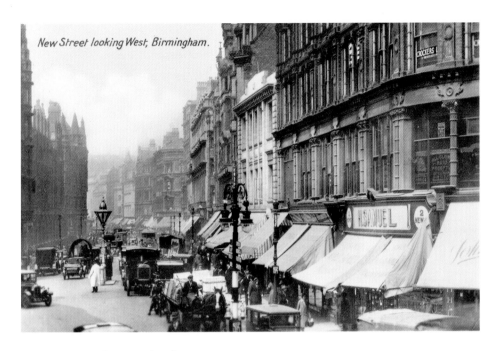

New Street looking West, Birmingham.

New Street — Eastern Section

To the left of the white coated traffic policeman, a car emerges from Worcester Street. Chock-a-block traffic conditions have caused even the motorcyclist to place his feet on the ground. Dobbin and the wagoner are probably used to such jams. H. Samuel still sells jewellery. In the modern scene, there are still plenty of goods for sale but the only wheels in sight are those of a cycle patrol policeman. The atmosphere is one of relaxed shopping, chatting and resting. No-one gives a second glance at the 'strange' foreign dress of some of the pedestrians.

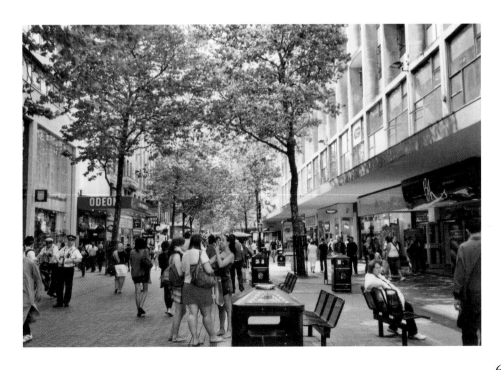

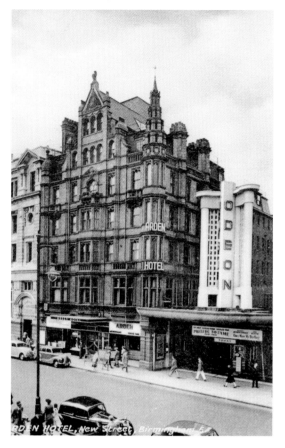

New Street — Eastern Section
Earlier known as the Hen and
Chickens (the site of a coaching
inn), the Arden was a temperance
hotel, closing in 1972. In
September 1937, the Paramount
cinema opened its doors to an
expectant public — 1,600 could
occupy the stalls with another
1,000 the circle. This new cinema
made a swashbuckling start
with dashing Errol Flynn in *The
Charge of the Light Brigade.* Later,
the Paramount became the fifth
Odeon in the city and remains
in business as an up-to-date,
multi-screen cinema. Incidentally,
Once More, My Darling (left) was
released in 1947.

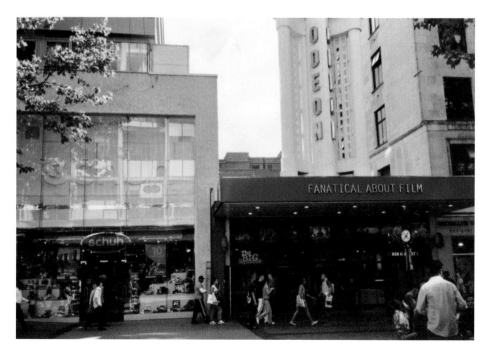

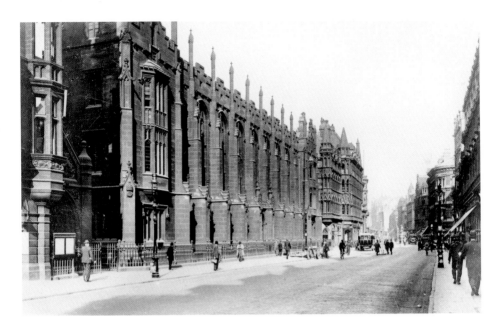

New Street — Eastern Section

The above school was the finest in the city for boys. Built in 1833, the building was designed by Sir Charles Barry, architect of the Palace of Westminster. The school eventually moved to a new building of modern 1930s style, on the Bristol Road, the above building being demolished in 1936. The cinema was built on part of the site created. Now, next to 'Fanatical About Film', stretches the clean-cut King Edward building.

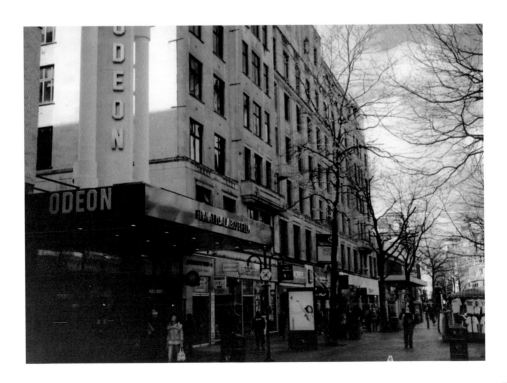

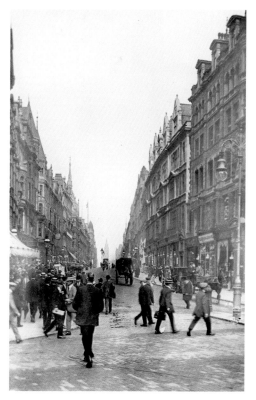

Corporation Street — New Street

The crossroads formed by New Street, east and west, Corporation Street and Stephenson Place (not visible) has long been a highly animated road junction. The postcard, franked 19 July 1917, shows the start of the 'boulevard' that had been dear to the heart of Joseph Chamberlain. Acres of slums were cleared away for the necessary redevelopment. Boaters, for men, are clearly popular and that landmark tower appears again. The 2009 scene has more of a boulevard atmosphere about it with trees in leaf, foreign dress, and an altogether more cosmopolitan atmosphere than in times past.

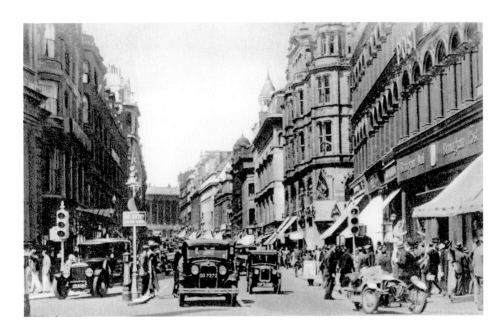

New Street — Western Section

From the driver's perspective (above), turn right for Stephenson Place and the station. Carry straight on into the eastern section of New Street, turning left for Corporation Street. Two iconic cars can be identified — the three wheeler Morgan and near it an Austin 7, the baby Austin. Above right are the premises of the *Birmingham Post and Mail*, major provincial newspapers. The fine corner building, left, served the Midland Bank for many years, and is now occupied, in part, by Waterstone's and Costa Coffee.

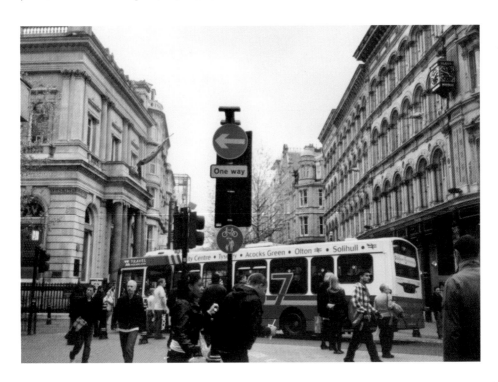

73

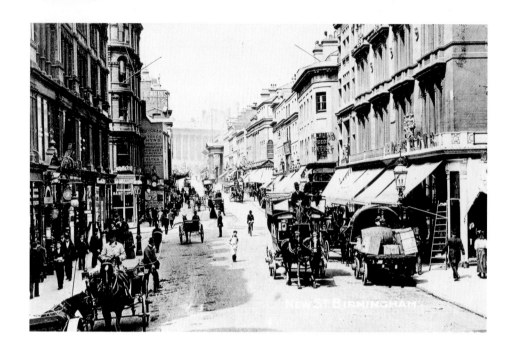

New Street — Western Section

On the postcard, franked 1904, the fine carriage, near left, has a uniformed coachman as driver. Just behind is a 'Creamery' of Birmingham Dairy Co. Almost opposite, Allwood plies his grisly trade of Dental Surgeon, long before the days of the high-speed electric drill. For modern shoppers in New Street, there is virtually no need to be on the alert for vehicles. Advertising remains prominent but in a format rather different from that of a century ago. Some shops are to let, a sign perhaps of the economic climate.

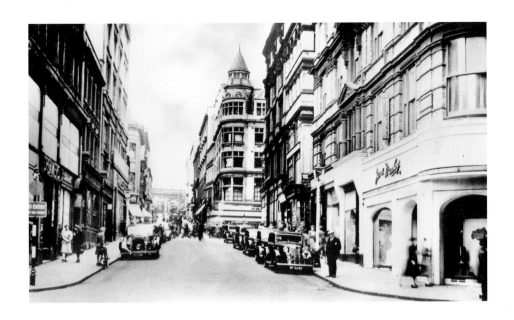

Lower Temple Street
The above street links
Temple Row, New Street and
Stephenson Street, its one-way
traffic status being made very
plain. Looking at the first car
right, if the pointed bonnet
supports a sphinx as a mascot,
then the car is an Armstrong-
Siddeley. In the distance, part
of St Philip's Cathedral can
be seen, as is the case from
New Street in the photograph
below. Lamp standards, in
their design, seem to hark back
to their lantern-like past.

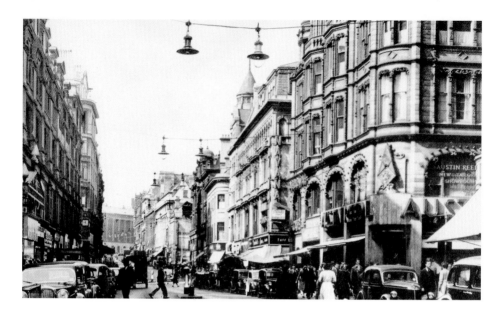

New Street — Western Section

The postcard depicts another animated street scene with parked cars playing a waiting game before setting off again. By contrast, the animation below is exclusively human in character. In the space created by the junction of Temple and New Streets, a group of youthful backpackers, heading for a jazz festival, pause by a modern (advertising) totem pole. Among them is a French lad, wearing a kilt, apparently very much *à la mode* wear *chez lui*. The postcard does seem rather staid, but then the 1930s had plenty to be staid about.

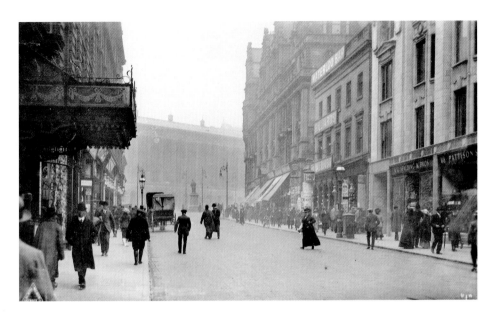

New Street — Western Section

On the postcard, the lighter coloured, newer-looking shop fronts belong to Spalding's, who sell sportswear and sports gear, with Pattison's next door, a company well known for its classy confectionery and cafés. The next building to the left houses the Waterloo Bar. On the photograph, the red and white sign, right, reads, 'Give Blood Here', an indirect reminder of how far medicine has advanced since the days of the earlier scene. The Iron Man, close to the Town Hall, looks a bit rocky on his pins!

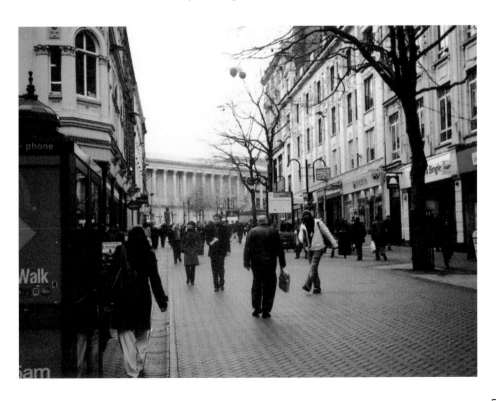

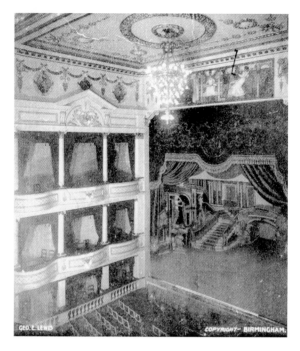

New Street — Theatre Royal

Held by many to be the city's top theatre, a more appropriate name might have been the Phoenix, the building having been burned down and rebuilt more than once. As well as high drama, like Michael Redgrave's Macbeth in 1947, popular musicals were staged: *The Maid of the Mountains*, 1922, *Me and My Girl*, 1937, and, of course, pantomime. For instance, *Puss in Boots*, starring comedian Sandy Powell — 'can you 'ear me mother?' Part of the postcard's message reads, 'Are you getting any fog for the season? Can't breathe here'. The Royal lasted from 1774 to 1956, as the plaque from the Birmingham Civic Society shows.

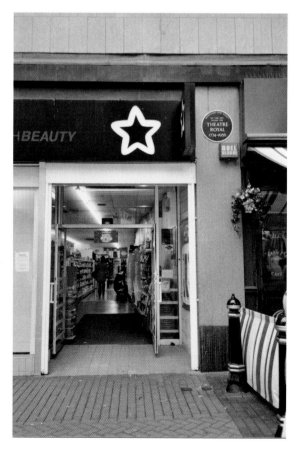

New Street — Western Section

This bar was situated on the corner of Christchurch Passage, which linked New Street with Waterloo Street. Conceivably, repetition of the bar's identity might have made thirst grow stronger, and the billiards facilities would have attracted sporty customers and sharp-witted commercial travellers. Billiards still prevailed over snooker as a popular table game. No doubt, wagers were made. Now, it is up to the Halifax Building Society, with others, to evaluate risks of a different order.

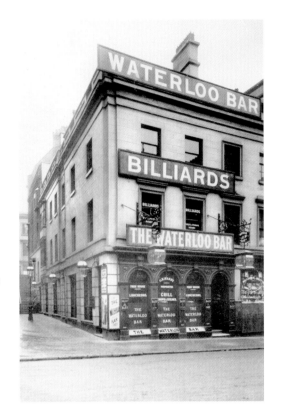

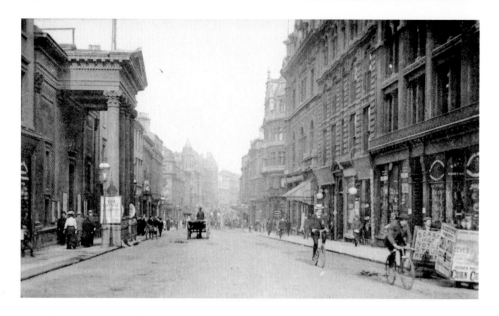

New Street West, Looking East

The impressive portico of an art gallery, referred to earlier, displays a placard bearing *Vox Populi* (public opinion) regarding an 'exhibition' of some kind. What the public made of this phrase, who can say? The messages across the way, carried by the sandwich-board man and a colleague, completely encapsulated would be plain enough to the *populi*: Boards Vault Hotel Stout House and Reeves Corn Cures. Something of the old time market stalls shopping in this modernised street is recaptured on the first and third Wednesdays of every month — care for some fudge? Sometimes a special international market of this kind, but principally of foodstuffs, is held, all flags flying.

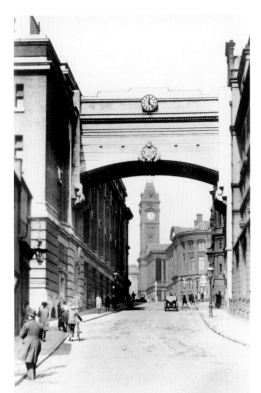

Hill Street

As mentioned earlier, this bridge connected two types of post office operation. By chance, the bridge added interest to an ordinary sort of street and provided a more photogenic view of the council house and the city's 'Big Ben'. One of the many Royal Mail red vans can be seen in the recent photo. The coach signed 'Millennium Travel' invites speculation as to its itinerary and passengers. Double yellow lines seem a natural part of the scenery.

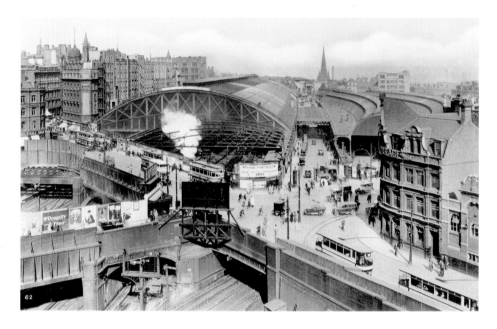

New Street Station

Trams wait in Navigation Street either side of Hill Street shown left, flaunting a fine display of adverts. At ground level, the two parts of the station are separated by Queens Drive. The far end of the drive ran into Worcester Street where the rear entrance to the historic and much-loved market hall can just be seen. To the right rises the spire of St Martin's Church. Then, as now, taxis were in demand — first as horse-drawn hansom cabs, then those shown on the postcard, and later still, as on the photograph, in a much-truncated Queens Drive.

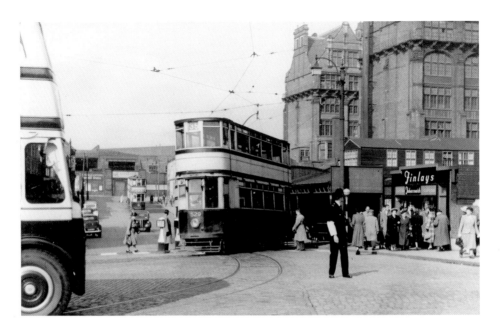

Navigation Street

The semblance of a head-to-head, with the policeman as referee, is, of course, highly fanciful. In reality, Corporation tram and bus services worked well together for some years before trams, on grounds of less mobility and greater cost, had to yield to buses, with all trams replaced by buses and trolley-buses by 1954. The tram terminus in Navigation Street provided services to the southern suburbs. That part of the street now dives under the flyover dual carriageway of Suffolk Street. Redevelopment continues, 'presided' over by Alpha Tower. Hill Street, on the right, runs up towards the Council House.

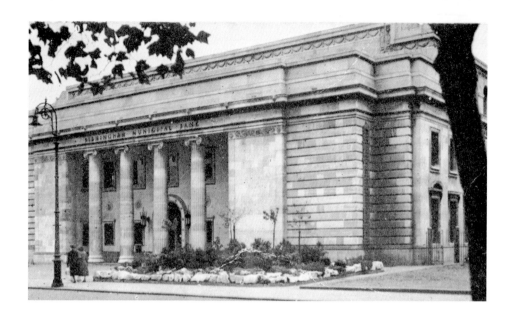

Bankers of Broad Street

The above building was opened in 1933 as the head office of a bank founded in 1916, essentially to help the war effort and to serve as a savings bank for the man in the street. As the Chancellor of the Exchequer during the early 1920s, Neville Chamberlain (future prime minister) was a strong supporter of the bank, which developed many suburban branches. Eventually the bank became part of the Lloyds Banking Group, and this old head office still exudes an aura of prudence and probity.

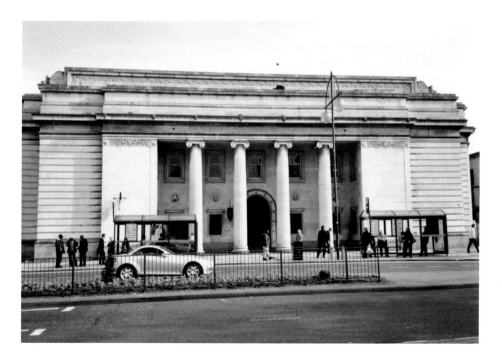

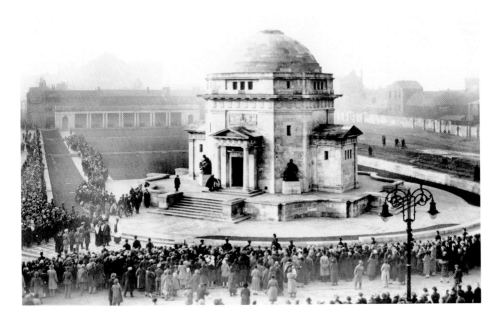

Hall of Memory, Broad Street

The postcard reflects an all too sad a moment for all too many people. The city's memorial to the Birmingham fallen of the First World War, 'the war to end wars', was built during 1923-4. Two of the four bronze statues can just be seen, the four representing the Army, Navy, Air Force and Women's Services. The building is of Portland stone and inside the octagonal domed structure is a hall which contains a book of remembrance. The Hall also serves to commemorate those who fell during the Second World War.

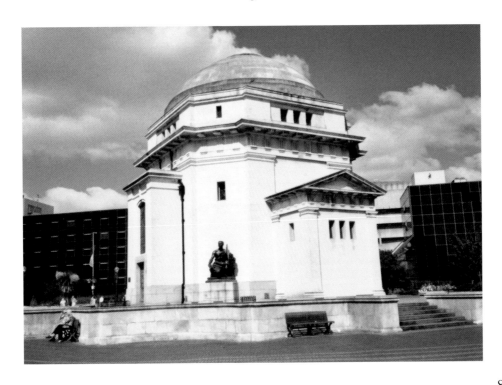

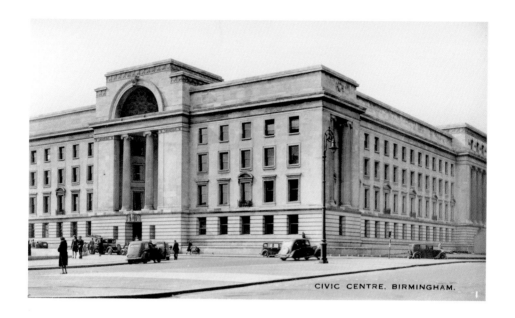

CIVIC CENTRE, BIRMINGHAM.

Baskerville House, Broad Street

The above building, named after the famous eighteenth-century printer (as was a universally admired typeface he created), formed part of the 1930s 'grand design' for a new civic centre. Implementation of the design was scotched by the outbreak of the Second World War. The building was hurriedly completed in 1939, serving as municipal offices. It is now available for commercial offices. Among its prestigious neighbours are the Repertory Theatre and Symphony Hall.

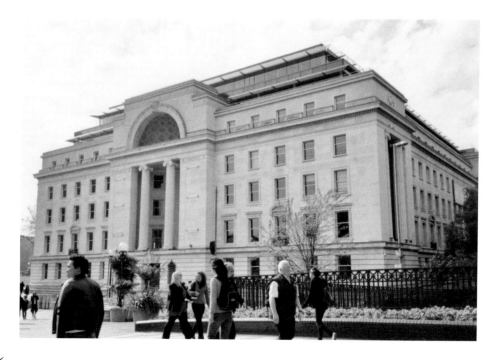

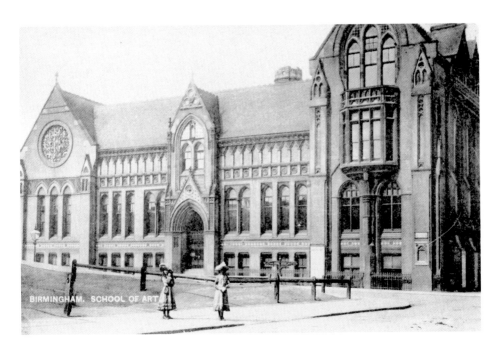

School of Art

This fine building stands at the corner of Margaret and Edmund Streets, the school being opened in 1894. The cost was largely met by Louisa Anne Ryland, a noted Birmingham philanthropist who also bequeathed land for the creation of Cannon Hill Park. On the green patch where the girls are standing, municipal offices were subsequently built. It would take keen and detailed study to determine whether, in 115 years, the front of red brick, terracotta and tile had changed in any material way. The institution itself has risen, in stages and status, to become part of Birmingham City University, formed in 1992.

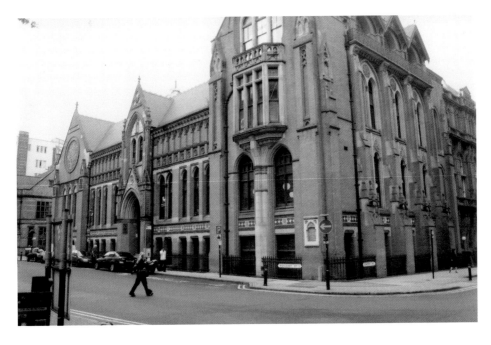

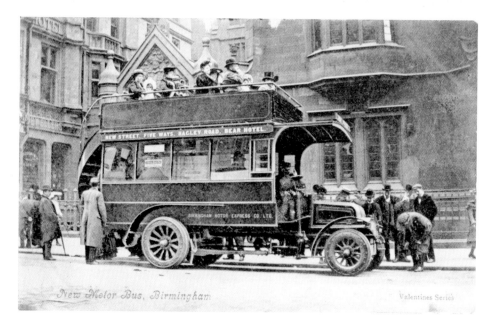

New Motor Bus, Birmingham Valentines Series

Transport — Buses

Above is a bus from the early years of the twentieth century. At this time, top deck
passengers, driver and conductor were expected to display a marked degree of fortitude,
for obvious reasons. Modern passengers travel in a far plusher comfort zone. There is
even allocated space for those folding, rather tank-like children's buggies. The old bus was
photographed in New Street by the boys' school and the new one in Colmore Row. On
the top deck and seated at the back is a policeman — keeping his eyes on a grey haired
photographer perhaps?

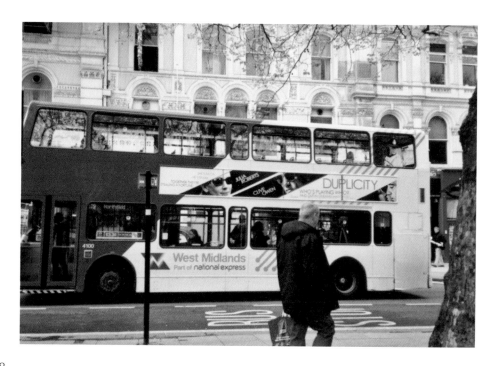

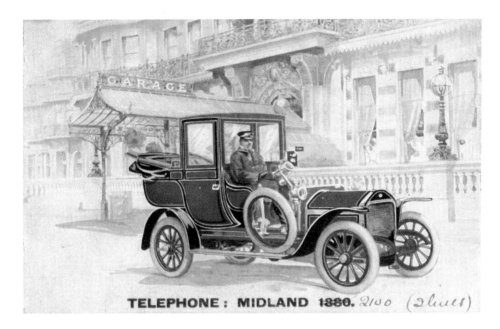

TELEPHONE : MIDLAND 1880. 2100 (2 lines)

Transport — Taxis

The above card was issued by The Provincial Motor Cab Co Ltd to advertise its taxi services. Details on the back include: '18-25 hp Siddeley Cars. Luxuriously Upholstered'. Fares are quoted but 'No Extra At Night'. This delicately coloured sketch seems designed to appeal to well-heeled passengers, those who might favour a hotel moving with the times in having a garage. The company's garage was located in Edgbaston, no mean suburb. Taxi fares are now affordable for many, and below is a cabstand in Colmore Row, close to the entrance (stone balls), of Snow Hill Station.

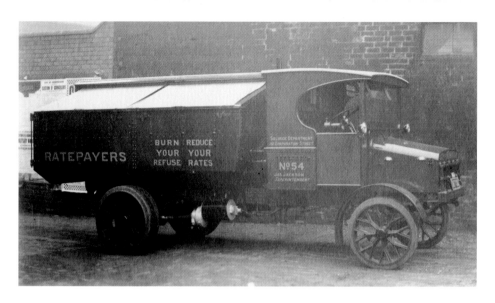

Transport — Salvage

'Salvage' on the cab door is indicative of the Council's long established approach to the removal and treatment of household and commercial waste. The First World War had concentrated minds on the value of salvage. Rescued for re-use were metals, papers, bottles, and so forth. Other waste was incinerated in destructor plants built in different parts of the city. For many years, most households burned coal for warmth and literally mountains of ash were cleared away from the backyards of homes of every kind. Today, dustmen no longer have to balance on their cap-covered heads tin baths full of all manner of rubbish, and we are all aware of the benefits of recycling. Green does seem the right colour for that vehicle sporting the city's coat of arms.

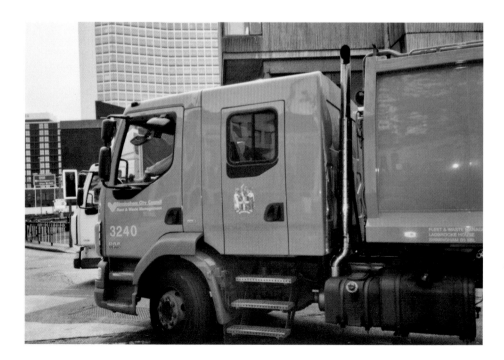

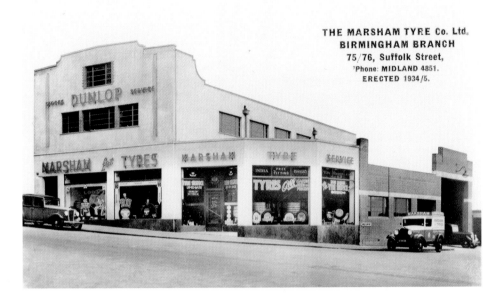

THE MARSHAM TYRE Co. Ltd.
BIRMINGHAM BRANCH
75/76, Suffolk Street,
'Phone: MIDLAND 4851.
ERECTED 1934/5.

Suffolk Street

Resuming the walkabout, the above showroom seems well stocked, especially with tyres from Dunlop's, at that time one of the city's major manufacturers and employers. Seventy five years on, the configuration of the two left hand windows appears to have been maintained with the corner site enlarged and greened. Cars whizzing down the hill's dual carriageway will need to slow down to enter Swallow Street, Brunel Street or nearby car parks. Coffee rooms pre-dated the confident garage and more changes are under way, another example of Birmingham's resilience.

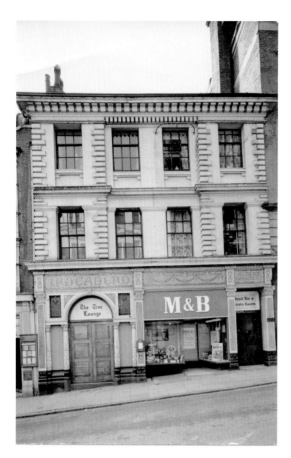

No. 18 Temple Street

Before becoming part of the Mitchells and Butlers brewery empire, this pub had been an Atkinson's house, Atkinson's being an Aston brewery. The building, dating back to the mid-nineteenth century enjoys Grade II listed status. The pub's frontage has long been a notable glazed yellow. Outwardly, a few things have changed, 'M & B' has disappeared, and four overhead lanterns, two large and two small, have been added. And note the presumed safety measure — a chequered warning of 'mind the steps'. The lone smoker also needs to watch out.

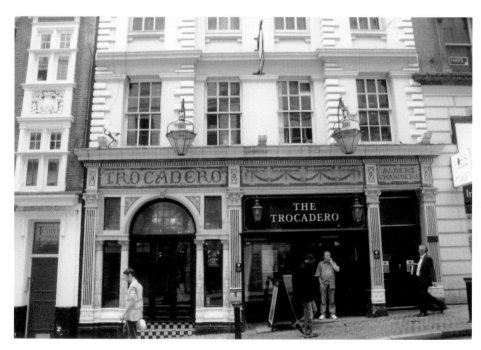

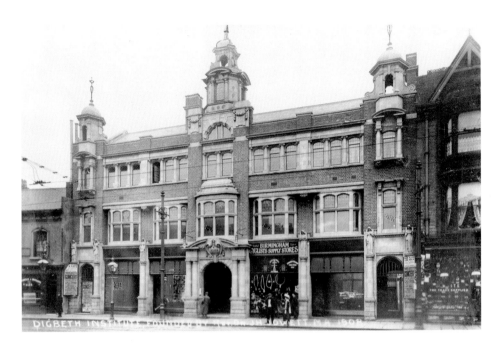

Digbeth Institute

Founded in 1908 by the go-ahead Dr J. H. Jowett of Carr's Lane Church, this institute was literally a godsend for those people in a slum area who sought to better themselves. Religious and social facilities included a chapel, a reading-room, a gym, various rooms for billiards and games, music, meetings, teaching and learning. Closing in 1954, another change is currently taking place behind plastic sheeting. But note what is said below 'plug' and that the building is a next door neighbour of the Kerry Man.

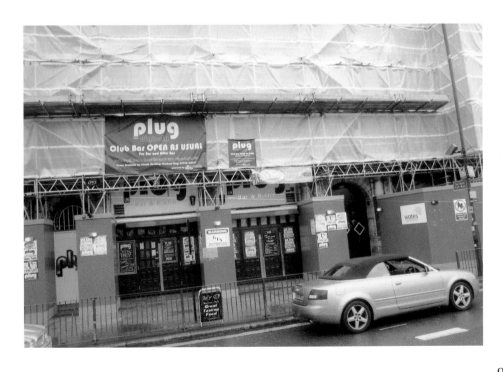

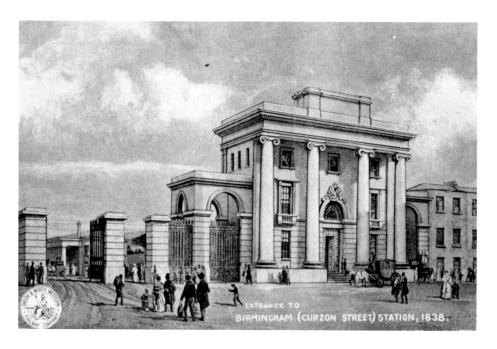

ENTRANCE TO
BIRMINGHAM (CURZON STREET) STATION, 1838.

Curzon Street Station

Franked 11 June 1906, the above postcard presents an artistic depiction of the then town's first station terminus for the train journey between London and Birmingham, the railway company being shown on the card. This handsome Grade I listed building, just east of the Bullring, deserves to be in a far better setting than this badly neglected 'siding'. This photo, taken from a moving train, offers a glimmer of hope for redevelopment, given the amount of space available and the proximity of the cranes.

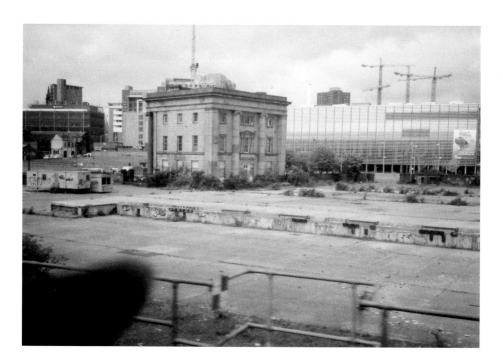

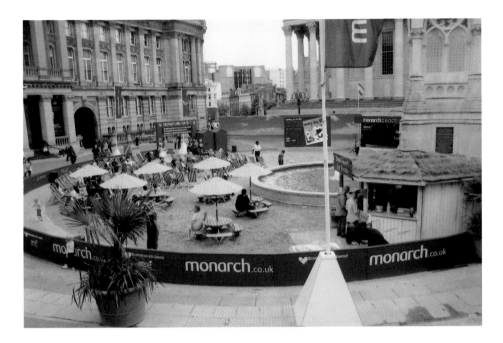

Birmingham 'On Sea'

What's this? A topsy-turvy page with the 'now' photograph at the top? Well, it's that sort of occasion, July being the month when the Summer Beach event starts — when sand by many a bucketful is spread about Chamberlain Square. This year the event is sponsored by an airline, promoting holiday fun via sight, sound, food, and ample deckchair relaxation. Stewards keep watch that beach etiquette is observed. This 'taster' might encourage people to book holidays abroad including 'Gran Canaria, Africa, Menorca', advertised on the blue band but not on the photo. This unusual event continues until mid-September.

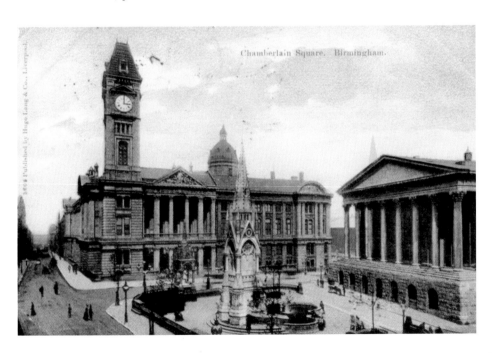

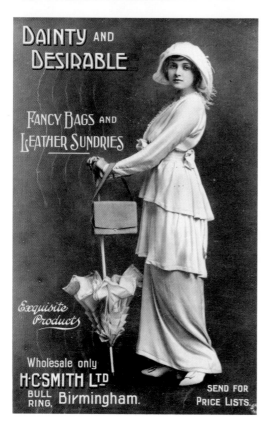

Bullring — Shopping

Fashion can be an instructive way of identifying how things change and the Bullring has long been a fascinating showcase for all manner of changes. During the first half of the last century the Bullring was home to a wide variety of independent traders. Now, it is more a question of large shops within tiered, even larger shops. No attempt is made here to compare and contrast the two illustrations except to say that both merit close scrutiny. The postcard is franked May 1919, so the costumes are at least a century apart. Was the double meaning intentional? We shall never know.

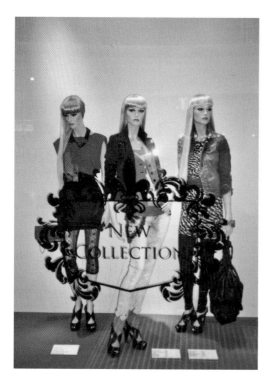